STUFFED ANIMALS

A MODERN GUIDE TO TAXIDERMY

*Divya Anantharaman &
Katie Innamorato*

The Countryman Press
A division of W. W. Norton & Company
Independent Publishers Since 1923

NOTE TO READERS: This book is intended to guide and entertain the reader, not to substitute for legal or professional advice. Neither the publisher nor the author of this book guarantees its accuracy and completeness for all purposes or makes any representation with respect to the outcome of any project or instruction described. Readers are cautioned to consider their individual circumstances and location before undertaking any do-it-yourself project and to avail themselves of appropriate advice to ensure that they are in compliance with all applicable laws, rules, and regulations. Please be aware that exposure to certain commonly used chemicals has been associated with symptoms that include skin irritation, respiratory difficulties, and damage to fertility; **these chemicals must not be used in any project if the meat or any other byproduct is intended for consumption by humans, pets, and/or other animals.** When using any chemicals, please be sure to review the manufacturer's directions and the material safety data sheets (MSDS) and use proper personal protective equipment. References to specific products, services, service providers, and/or organizations are for illustration only and none should be read to suggest an endorsement or a guarantee of performance. This book is sold without warranty of any kind, and none may be created or extended by sales representatives or written sales or promotional materials.

For information about permission to reproduce selections
from this book, write to Permissions, The Countryman Press,
500 Fifth Avenue, New York, NY 10110

For information about special discounts for bulk purchases, please contact
W. W. Norton Special Sales at specialsales@wwnorton.com or 800-233-4830

Manufacturing through Asia Pacific Offset
Book design by Melanie Ryan
Production manager: Devon Zahn

The Countryman Press
www.countrymanpress.com

A division of W. W. Norton & Company
500 Fifth Avenue, New York, NY 10110
www.wwnorton.com

978-1-58157-332-9 (hc.)

10 9 8 7 6 5 4 3 2 1

To our friends, family, and those who have supported us

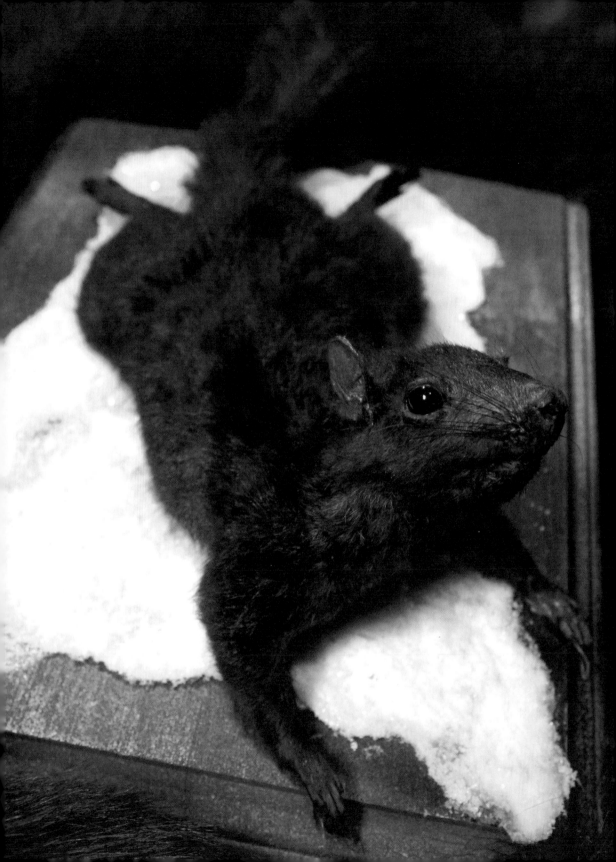

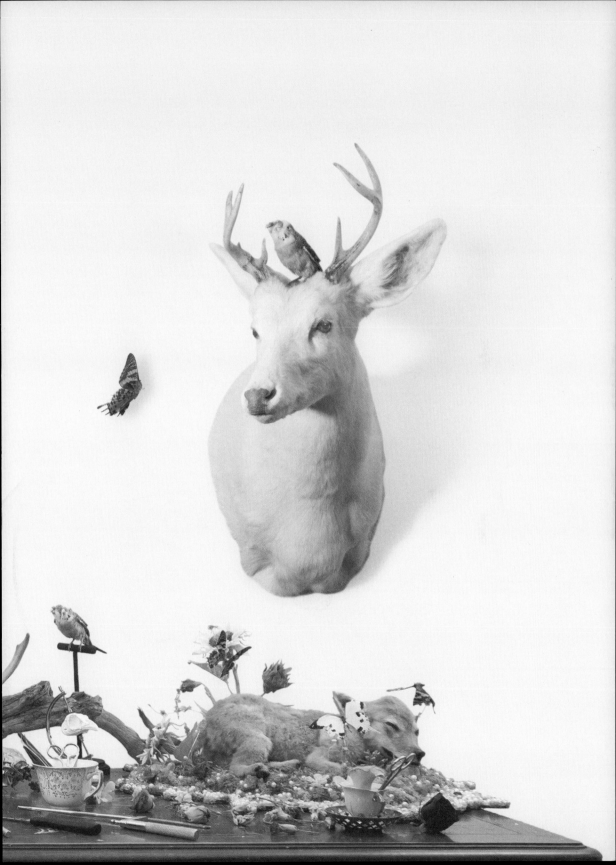

STUFFED ANIMALS

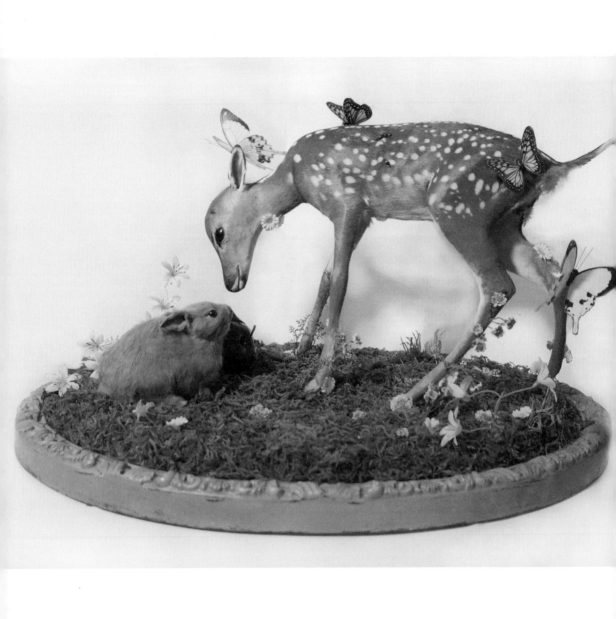

CONTENTS

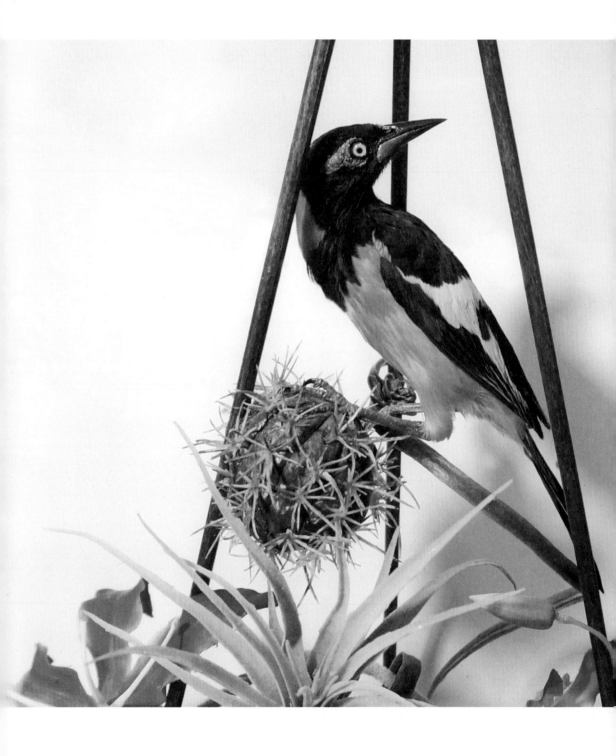

INTRODUCTION

WHY TAXIDERMY?

Perhaps you've picked up this book after a visit to some edgy art gallery and want to know how those snakes became so perfectly posed and lifelike. Or you're fresh from a visit to the natural history museum and want to know what exactly is underneath the fur and feathers in those splendid dioramas. Maybe you are wondering if there is anything you can do with the roadkill you keep driving by, or you are envious of your crazy uncle's jackalope. Or maybe one of your friends got you this book on a dare.

Whatever drew you in, you've made a great choice! Taxidermy is a mix of art, science, and a little alchemy; it lets you explore and engage with the natural world in ways most others don't. We hope this book demystifies the practice, makes taxidermy accessible to anyone, anywhere, and shatters the gross stereotypes (like the common misconception that taxidermists produce nothing more than "stuffed animals"—most taxidermists cringe at this term and its crude origins).

And why not? Humans need the outdoors to survive. Even if you live in the city, you feel happier when looking at green things, warm things, and furry things (and feathery things, and scaly things, etc). Reclaimed wood, leather, and even houseplants are remnants of nature that we bring indoors in an attempt to reconnect. Does anybody really want to live in a plastic house? Taxidermy is all about appreciating nature, preserving and paying respect to something that would otherwise be left to rot. Some people see it as morbid, but we see it as being comfortable with—

and accepting of—the inevitability of death. Aside from its scientific and artistic purposes, taxidermy serves as a beautiful reminder of our own mortality, capturing the ephemeral in a perfect moment.

That moment can be whatever you want it to be. It can be something straight out of a woodland, a fantasy-fueled concoction meant to push the limits of perception, or something totally different that you wouldn't have imagined until you created it. Taxidermy today is experiencing a renaissance that is probably due to a renewed interest in making and collecting, as well as the fresh accessibility of ideas that were once obscure. Traditional taxidermy mounts are now incredibly lifelike, with new materials providing more possibilities than ever before. Alternative taxidermy mounts offer endless possibilities too, as an animal can become absolutely anything in the hands of an artist. New blood brings new ideas!

We came to taxidermy in different ways. Growing up in inner-city Miami, Divya was more used to weekend beachcombing and backyard mischief. She felt strangely drawn to her parents' biology books and classrooms full of specimens. She was

always curious about how the inside and outside of an organism worked together, and what special features an animal develops to adapt to its environment. Her art school projects used fur, leather, bone, wool, silk, and other animal products, and though taxidermy was always an appealing hobby, she never really considered a career in a field that has traditionally been relegated to Victorian gentlemen's clubs and hunting lodges. But after ten years in the fashion industry and improving her skills through self and professional training, she finally found her calling.

As for Katie, she has loved animals for as long as she can remember. As a kid, she would play outside and pretend to be an animal with the neighborhood kids. Whenever anyone asked her what she wanted to be when she grew up, the answer was a veterinarian. Toward the end of high school, she became intrigued by skeleton articulations and started picking up rotten roadkill (much to her parents' displeasure). Very loose and basic articulation creations came after this, but the idea of using everything stuck in her head. What about using something fresher? How could you prepare or process it? Local taxidermists mostly turned her away except for one older guy who taught occasional classes. Katie learned the basics from him and progressed from there. There was no looking back.

When we met through teaching workshops and being part of some of the same gallery shows, our shared love of animals (and *Golden Girls,* and spicy pickles) made it easy to become friends. We cross paths with all sorts of people at the classes we teach— aside from artists and naturalists, we've taught accountants, soccer moms, true-crime voice actors, strippers, and finance bros. Even Audrina Partridge from *The Hills* walked away with an anthropomorphic mouse, dyed purple and dressed as a flapper. The wide availability of ideas on the Internet makes it easy to connect with different communities. Some attend these classes to meet like-minded individuals. These classes make taxidermy more accessible to people who are curious but may not be ready for weeks-long schooling. More people are moving to big cities and living far from nature, and taxidermy offers a way to reconnect with the natural world. Though taxidermy is not new, we think it is gaining popularity. In an increasingly digital world, taxidermy lets you work with your hands and come away from a project with a tangible object. We are part of a new generation that is interested in both the craft and preci-

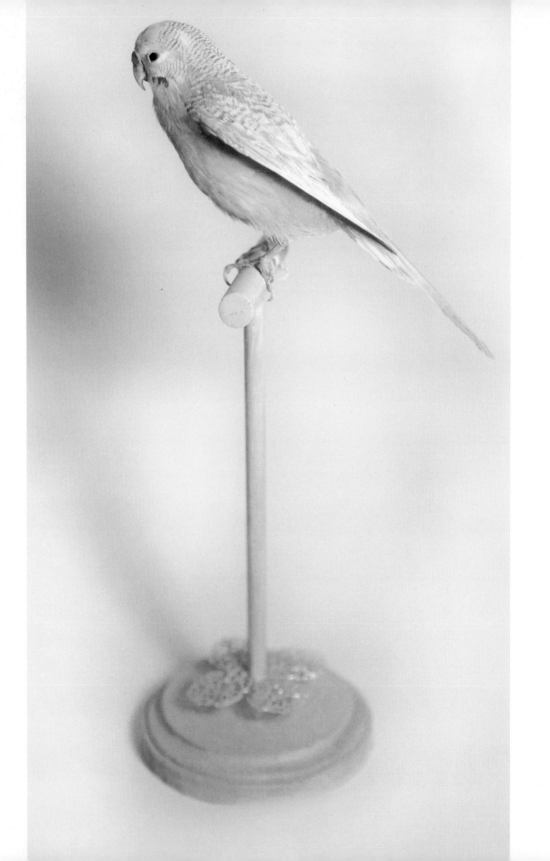

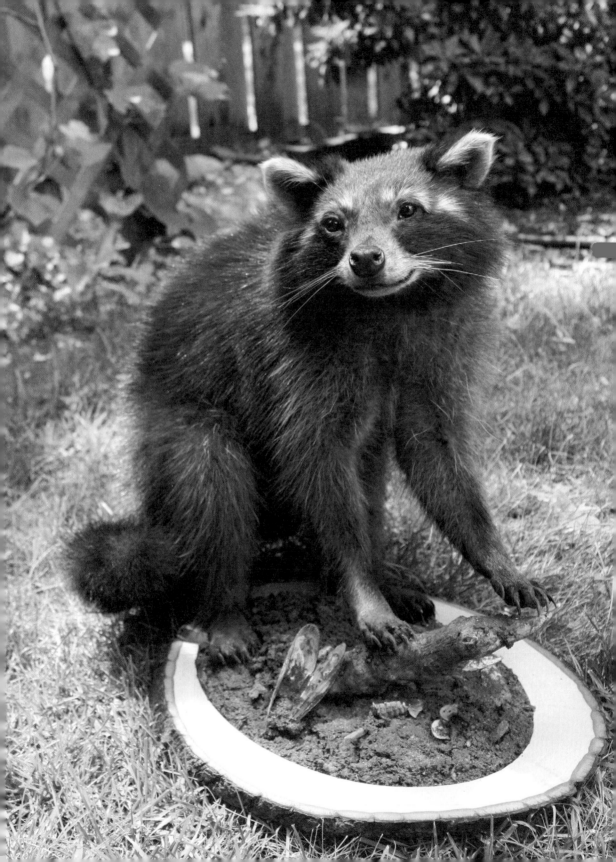

sion of traditional taxidermy and in pushing the boundaries to allow each person's unique interpretation to come through.

We love taxidermy because we get to use our hands, do something creative, and share our passion with others. That's all we've ever really wanted. If this book makes you want to get outside, become more mindful of nature, meditate on mortality, or even try mounting something yourself, then we've done our job.

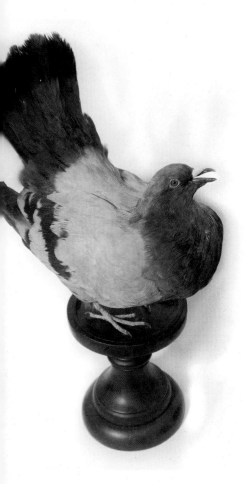

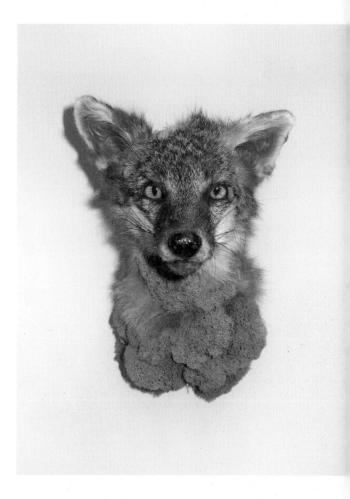

CHAPTER 1
THE HISTORY
OF TAXIDERMY

There's more to taxidermy than musical coyote vivariums and stilettos decked out with battling sparrows. It is an ancient art that can be traced back to Egyptian mummification and hide preservation. The chemistry used in those ancient processes played a huge role in the way we learned how to slow—and eventually stop—decomposition. Long before the invention of photography (let alone Google Images or viral videos), new and exotic animals preserved in faraway places enchanted inquisitive naturalists and wealthy collectors.

As the Silk Road and trade routes between Asia and Europe opened up in the Middle Ages, so did humanity's appetite for knowledge. The pleasures of silk and cinnamon may have sufficed for some members of the privileged class, but it is human nature to always want more of what you seemingly can't have. Imagine seeing a peacock for the first time and then trying to tell all your friends back home about it without any photos or drawings.

To sate this hunger for knowledge (and to be able to show everybody back home) traders began preserving skins as opposed to whole animals—much more practical than dealing with the logistics of transporting a whole, heavy, and perishable beast (to say nothing of the dangers of transporting live ones). This was the beginning of

many famed cabinets of curiosities that would later become the natural history museums we revere today. The wondrous animals brought back to taxidermists from expeditions in far-off lands had never been seen before, and most people questioned whether some of them were even real.

The oldest surviving pieces of what we would consider taxidermy date from the 1600s (a crocodile on display at the Natural History Museum in Switzerland; a full-size stag on display at the Danish Museum of Hunting and Forestry; and at Westminster Abbey, an African Grey Parrot that belonged to the Duchess of Richmond). By the eighteenth century, almost every town had a tannery, which helped to spur industrial revolutions of all sorts (leather goods! furniture! shoes!). In the nineteenth century, hunters began bringing their trophies to upholstery shops, where the upholsterers would actually sew up the animal skins and stuff them with rags and cotton. The terms "stuffing" and "stuffed animal" have their origins in this crude form of taxidermy. Today's taxidermy is much more sophisticated. You can put two heads on something, give it a green nose, or name it after Aunt Betty—but please, please, please don't actually "stuff" it!

All art forms have a Golden Age, and for taxidermy this was unquestionably the Victorian Era. Industry was booming, and the widespread fascination with death (elaborate mourning, rituals, postmortem photography, and *memento mori*—things we both swooned over as young goth kids—were quite common) mixed with a growing interest in science to make taxidermy the hot new thing in art. Artists strove to create convincing, lifelike mounts for their homes and for museums. Women, traditionally the caretakers and preparers of the deceased, would do fancy work and mount specimens like birds, whereas men, who more frequently hunted, dominated the mammal scene.

After the Victorian Era, our society shifted in response to the noticeable decline and obliteration of a number of species. We realized that we were taking much more from the environment than could be naturally replenished, and this realization was the beginning of modern conservation laws and the temporary decline in the popularity of taxidermy. Although every

part of the animal was used and numerous scientific advances were made, taxidermy seemed to have left a bad taste in everyone's mouth.

But a new Golden Age is starting now. Our nostalgia for a vanishing natural world has sparked resurgence in cabinets of curiosities and oddity collections as well as an interest in sourcing animals legally and sustainably. Technology has an increasingly strong hold on our lives, and now more than ever we are removed from the visceral reminders of life's building blocks. It is easy to see our renewed interest in death on display in popular culture, and it is only natural that we are using our modern privilege to take the natural world back into our own hands.

THE TAXIDERMY HALL OF FAME

There are so many amazing books out there that tell you everything you could possibly want to know about the history of taxidermy and preservation—much more than we could ever cover here. But we'd be remiss if we didn't spotlight some of our favorite taxidermists through the ages. Their lives show how the art grew and evolved into what it is today. Our focus is on people who have inspired us personally; hopefully you'll find a story that resonates with you, too.

FREDERIK RUYSCH (1638–1731) AND RACHEL RUYSCH (1664–1750)

This father-daughter team was known for their work creating beautiful preserved anatomical specimens. A botanist and anatomist, Frederik Ruysch was known not only for pioneering preservation techniques that made for long-lasting, lifelike wet and dry specimens. He was known for his meticulous dissections and his desire to make beautiful study specimens that would foster interest and education—even in the seventeenth century, students needed entertainment to stay focused. His daughter Rachel, a still life painter, helped her father to create artful dioramas and arrangements of preserved flowers, plants, dried shells, and preserved small animals. She also added details such as lace collars and silk ribbons to frame delicate body parts and make anatomy class just a little more interesting.

LOUIS DUFRESNE (1752–1832)

Louis Dufresne was a French ornithologist, taxidermist, and naturalist who, after numerous expeditions all over the world, became the curator of France's National Museum of Natural History—or *Muséum national d'histoire naturelle* to locals. He's credited for popularizing the use of arsenical soap in preserving birds in an 1802 article published in the esteemed *Nouveau dictionnaire d'histoire naturelle*. (Another French taxidermist by the name of Becouer was using arsenic before Dufresne, but unlike our buddy Louis, he never published his recipes.) Dufresne's article is credited by some as containing the first documented use of the word "taxidermy." As an extremely effective preservative, arsenic revolutionized taxidermy, and it allowed the museum to amass an extremely large collection of the most beautiful birds. By 1818, there were more than sixteen hundred mounted birds in the collection—not to mention, eggs,

study skins, fossils, insects, reptiles, amphibians, and insects. He was awarded the Legion of Honor in 1829 for his contributions to natural history and science, but he passed shortly after due to lung disease. The collection lives on at the Royal Scottish Museum.

JOHN JAMES AUDUBON (1785–1851)

John James Audubon was an American naturalist, ornithologist, and painter who identified twenty-five new species in his lifetime. He was born in Haiti as Jean-Jacques Audubon and immigrated to the United States in 1803 under a false passport his father obtained in order to help him avoid the Napoleonic Wars. There, he changed his name, befriended outdoor enthusiasts, and fell in love with observing and documenting nature, especially birds.

At age eighteen, he fell in love with Lucy Bakewell, a high-society Englishwoman raised in the type of home where her parents burned romance novels that made her giggle. So they got married against her parents' wishes, and they left the fancy life for skinny-dipping and birding in the wilds of Kentucky. One day, Audubon came across an ornithology book with some bad drawings. Like, really bad. This drove Audubon to eventually produce some of the most realistic illustrations of his time, which can be credited to his knowledge of taxidermy and unique working style.

Lucy encouraged his drawings; they appealed to the refined taste in art she had developed during her fancy upbringing. The dead birds made her fall in love with him even more, and they decided to pursue his art full-time—just as the economy turned south, their store went under, and two of their four kids died. Lucy took a job as a teacher while Audubon traveled the world and pushed his art, keeping her at an unhappy distance.

His travels earned him a reputation though, and *The Birds of America*, a full-color illustrated volume depicting every bird in America in its natural habitat, took more than fifteen years to make. Lucy and John eventually reunited, but age and dementia took his life. The debts run up by her husband left Lucy with no choice but to sell his paintings and book plates.

CHARLES DARWIN (1809–1882) AND ALFRED RUSSEL WALLACE (1823–1913)

When the word evolution comes to mind, we immediately think of Darwin but always seem to forget about Wallace. Poor guy! Wallace independently studied and conceived ideas of natural selection and evolution around the same time as Darwin. By the 1870s, most of the scientific community and the general public accepted evolution and the scientific information around it as fact (even though people still argue about it today). On their numerous collecting trips, Darwin and Wallace's journals and preserved specimens were crucial both in demonstrating and supporting their ideas and in communicating what they observed to the scientific community back home. Wallace even wrote the 100-page "Manual of Taxidermy," an instructional book detailing the preparation, skinning, preserving, and mounting of mammal and bird specimens. By doing taxidermy and closely studying animals, they were able to demonstrate their revolutionary scientific ideas to a skeptical public. Who knows what would have happened if they did not use taxidermy!

JOHN EDMONSTONE (1793–1822)

A freed black slave from Guyana who lived a few doors down from Charles Darwin, Edmonstone made his living teaching taxidermy to Edinburgh University students and mount-

ing birds for the Natural History Museum. He and Darwin befriended each other and often spoke about Edmonstone's tropical home and its natural wonders, going into great detail about the wild and wonderful plants and animals. He taught Darwin the art of taxidermy, a skill that would prove vital to the collecting trips Darwin undertook onboard the HMS *Beagle* and that also ensured specimens didn't rot or look derpy when he got home. Edmonstone may have also influenced Darwin in other ways; the members of Darwin's extended family were opposed to slavery, and Darwin's ideas about evolution challenged notions of racial superiority.

JANE TOST (1817–1889) AND ADA ROHU (1848–1928)

This mother-daughter dream team of lady taxidermists created an incredibly successful taxidermy business in Australia. They catered to both a growing middle class that desired taxidermy as interior decoration and to museums seeking lifelike work. Born in London, Jane Tost trained at the British Museum and was the mother of six children. She and her husband moved to Australia, where her first job was preserving specimens for Royal Society of Tasmania at the Hobart Town Museum. After moving to Sydney in 1860, she became a taxidermist at the Australian Museum, making it clear she would not work for less than what her male counterparts made.

Ada was Jane's third child, and after an acting career and the unfortunate death of her husband and son, she joined her mother in business. They worked together on pieces for customers and museums, and regularly showed their work at international expos. Word spread quickly about the skill, talent, and detail that went into their work, as well as the way they accurately and beautifully portrayed Australian animals. They

won more than twenty medals for their work and became the faces of a larger movement of women in taxidermy.

WALTER POTTER (1835–1918)

A self-taught taxidermist and museologist, Potter mounted more than 10,000 animals during his time alive in the Victorian Era. His family owned a pub in Bramber, and as he amassed a body of work, it was displayed there. As the popularity and quantity of his work rose, he built a separate exhibition space, and at one point his work was attracting so many tourists that the town needed to add an extension to its rail station!

Although his work was not very technically adept or ana-tomically accurate, it spoke to the social and cultural climate of the time. His first mount was a pet canary of his that had died, but his most popular works are "The Death and Burial of Cock Robin," "The Kitten Wedding," and "Rabbit School." After his death, the popularity of his work declined and its cultural significance was overlooked, some even seeing the work as in bad taste (this was during an era in which it was totally normal to drown feral kittens rather than spay or neuter them). Despite attempts to buy the collection in order to keep it together as a whole, it was eventually auctioned off to multiple collectors.

QUEEN VICTORIA (1819–1901)

The famous Queen was an avid collector of taxidermy. Rumor has it that she actually cracked a smile when she viewed the whimsical anthropomorphic work of Walter Potter—she found it "amusing." A number of factors contributed to the popularity of taxidermy during her reign—the general obsession with death and dying, the rise of the cabinet of curiosities, the social and political power of documenting and classifying natural

history, the booming tannery and upholstery businesses, the wealth generated by the industrial revolution, and even the repression and social mores of the day. (Ankles? No way! Dead stuff? Why not!) The Queen had a huge collection of birds and a number of other critters, and her subjects, in keeping with good taste, aspired to follow their leader.

MARTHA MAXWELL (1831–1881)

A favorite among early taxidermists and an inspirational badass, Martha Maxwell was extremely provocative and ingenious for her time period. She grew up learning the ways of nature through her grandmother, living among and closely watching her animal counterparts. She went to college, which was unheard of for a woman during her time, and would go out hunting on her own. She wanted to preserve animals so that others could enjoy and study them, and if she noticed that her collection was missing a particular animal, she would plan her next trip around finding just that animal. She began making internal structures for her mounts out of wood and metal rods, and made molds of animals to cast her own forms. She was one of the few taxidermists at the time who paid great attention to details such as natural habitats and nuances unique to each species, and whose mounts weren't stiff, inaccurate, or otherwise unconvincing.

THEODORE ROOSEVELT (1858–1919)

An American statesman and our twenty-sixth President, Roosevelt was an avid outdoorsman, skilled hunter, and lover of the natural world. One of his major priorities when he took office was wildlife conservation, and he established a number of national parks, forests, and monuments with the goal of preserving and educating the public about America's natural resources.

Throughout his life, he donated many of the specimens he hunted to the American Museum of Natural History in New York City (which his father helped found). One of the most notable specimens in the collection is a snowy owl he shot at 17 and mounted with the help of a man trained by Audubon. Although some saw acts like this as contradictory, he made it clear that his mission was studying and learning about nature, not just mindless or indiscriminate killing.

HARRIET LAWRENCE HEMENWAY (1858–1960)

In the late 1800s, women's hats were often adorned with the feathers of birds from around the world—owls, birds of paradise, parrots, egrets, jays, terns, herons, and anything else with wings and feathers. But in 1896 in Boston, Mrs. Harriet Lawrence Hemenway, a prominent woman of the social and cultural scene, called up her best friends for another sort of revolutionary tea party. She was disgusted at the accounts she read of plume hunters, who hunted and sold the birds in the name of fashion, and she wanted to do something about it. Over tea with her cousin, Minna Hall, they vowed to put an end to the senseless slaughter that was decimating ecosystems and organized a boycott of the hats among their high-society friends. More than 900 women joined and set a trend that spread all over America. Their conservation and educational efforts, which led to the founding of the Boston Audobon Society, resulted in great political power and laws like the Lacey Act, the Migratory Bird Treaty Act, and other significant efforts that sought to protect wildlife and regulate its harvest.

CARL AKELEY (1864–1926) AND DELIA AKELEY (1875–1970)

Carl Akeley is often credited as the father of modern American taxidermy. He worked at the Field Museum of Natural His-

tory in Chicago and the American Museum of Natural History in New York. In addition to being a talented taxidermist who sought to preserve animals in a lifelike way so that future generations could admire and enjoy them, he was an intrepid explorer and fearless hunter. He pioneered more accurate and lifelike anatomical replicas, and it has also been recorded that he fought and killed a leopard with his bare hands (of course, he had it mounted later). His lifetime of hunting eventually led to his becoming a major voice for responsible wildlife conservation.

His wife Delia was a great adventurer herself. She helped Carl on many of his hunts and was a sure shot. She even rescued him from an elephant attack after the rest of his crew thought he was too far gone. We owe a lot to the Akeleys and their fearlessness.

CHAPTER 2
ETHICS

Ethics are nothing new in the world of taxidermy; all good taxidermists follow a code of ethics that covers issues such as working within the law, having all the right paperwork and licensing, using legally harvested specimens, and following best practices with respect to quality craftsmanship and honest business. It doesn't matter if you make three-headed neon zombies from rats that died from old age or if you construct elk shoulder mounts and donate the meat to the homeless. Everyone follows their own code of ethics, and we are not here to argue about what's right for you. What you should think about is getting the facts, examining them rationally, and making a decision based on what you feel the most comfortable with.

Morals and ethics are incredibly subjective ideas, and it is dangerous to say one way is better than another. Some people feel best when the animals used are not killed specifically for the purpose of mounting them. Others have no problem harvesting an animal for its beauty on display and flavor on the dinner plate. Over the course of our relationship with animals, humans have always both objectified and humanized them. These ideas change over time and reflect the social norms of the day.

Take the passenger pigeon. What was once considered a nuisance that "blackened the skies like a plague" in the nineteenth century had been totally decimated

by the twentieth century, as a result of uncontrolled extermination and habitat destruction. Incidents like this have brought about conservation laws in many countries. Before the invention of the common veterinary practice of spaying and neutering domestic pets, drowning new offspring was considered a normal part of animal management in the Victorian Era, and was a source of many animals used by taxidermists like Walter Potter. Even fur goes in and out of fashion, and being on the wrong side of the trend can get you soaked by a bucket of red paint. The key to ethics isn't extremism, but improving and evolving by staying informed about the natural and man-made environments we live in.

SCIENTIFIC COLLECTIONS

To get a sense of how ethics can change over time, you need only to visit your local natural history museum. Until relatively recently, museums and other educational institutions routinely went on collection expeditions, harvesting the best of each species from places far and wide for scientific study and display back in the great cities.

Some of us may cringe at the idea of killing animals in the name of study, but we cannot forget that this was a different place and time. As controversial as these actions seem, collection helped us learn about animals and the environment, make scientific advancements, and eventually learn ways to do these things without resorting to overharvesting. (And if you think natural history has a checkered past, you wont believe what has been done in the name of medicine!)

Museums, zoos, and other institutions now work with, and even fund their own, conservation programs, spreading environmental awareness and putting money into habitat preservation. There are still collection expeditions, but they are well

researched and sensitively informed. Nobody wants to be seen as the jerk who killed something when they shouldn't have. The mounts in the museums that are kept on display may serve as a reminder of the past, but it cannot be denied that they present the stunning beauty and grandeur of nature for us to ponder and admire—especially for those who aren't traveling to the jungle anytime soon!

HUNTING

A few bad apples (poachers) and some outdated ideas have given hunting a really bad reputation. Hunting and taxidermy have a long history. Indigenous cultures past and present have

hunted for sustenance and used every part of the animal. Hunting only started to become a threat to animal populations in the modern era. The arrival of colonists created a market for fur and pelts, and many animals were hunted to extinction. Dignitaries and royalty were known for keeping menageries, and in some cultures hunting was seen as a pastime for aristocrats.

Today, especially in the US, hunting and conservation go hand in hand in thanks to regulations and constant monitoring by watchdog groups. Any harvesting done without the proper tags and permits, or done out of season, is illegal (exceptions

are made for pests). When thoughtfully regulated, hunting has been shown to help wildlife thrive, and the money generated from licenses provides an economic incentive to keeping wild land wild.

An oft-cited example is whitetail deer. Suburban sprawl has encroached on their habitat, and deer have adapted by avoiding predators and snacking on our readily available gardens and supermarket snacks. This has caused some deer populations to grow beyond the capacity of the land. State and local governments set the number of hunting licenses and tags issued to reflect the calculations made by conservation groups. A good hunter will never take a shot unless they know it will bring the animal down as quickly and painlessly as possible. They also know to not take a young deer or fawn, a buck that hasn't mated yet, a doe, or any animal that is in its prime and can contribute to the species.

Some argue that it's better to let deer regulate themselves and die their own natural deaths, but given what humans have already done to the environment, this isn't necessarily a practical or humane option. Leaving these animals alone could cause diseases that could affect the entire population negatively or a rise in pests such as ticks, all of which would negatively affect humans and other wildlife. By culling populations responsibly, hunters working under regulations feed families, donate to food banks, and contribute to the maintenance of the land through the money from licenses sold. Plus, in the age of factory farming, hunting tends to look better by comparison. Free range, organic, humanely sourced meat? It is easy to see how deer would fit the bill.

Even if you do not agree with hunting, we hope you try to understand how regulated hunting can aid wildlife conservation in a complex landscape where humans and animals overlap.

MODERN ETHICS

Over the past decade, a renewed interest in taxidermy among diverse groups of young artists has reinvigorated public conversations on ethics and taxidermy in general. These conversations include debates about what constitutes art and taxidermy, as well as the sourcing responsibilities of the maker. Many artists who claim the "ethical taxidermy" label are using roadkill, donated specimens, casualties from the pet industry, nuisance animals, scraps from other taxidermists, by-products from the food industry, or frozen feeder animals raised as food for carnivorous pets.

Even though none of the animals from sources listed above are explicitly killed with the intention of being mounted, opinions vary on what is and is not ethical. Roadkill is often unavoidable, but one can easily debate its merits, as the practice stems from human encroachment on the natural environments in which the animals live. A meat eater who believes in eating only wild meat may believe that hunting a deer, eating the meat, and mounting the hide is ethical. Someone who believes only in farming may feel more comfortable mounting culled chickens. Vegans and vegetarians might have an altogether different outlook. Nuisance animals like rats, squirrels, pigeons, European starlings, English sparrows, raccoons, opossums, foxes, and coyotes are routinely removed from properties where they are being invasive or destructive. Some states do not allow the rerelease of these animals due to concerns about disease or imbalances in the ecosystem, and actually sponsor the cull. Even beyond the human food industry, animal parts are thrown away or rendered down for pet food, beauty products, or other commercial uses (illustrated beautifully by Christien Meindertsma, author of *Pig 05049*, which shows that even your cell phone isn't vegan).

The truth is that there is no one code of ethics written in stone, and given that factors like the economy, environment, and cultural context vary so widely, arguments declaring that there is some all-purpose ethical code add up to little more than hot air. We can all agree to a "waste not, want not" philosophy and encourage educated discussions on sourcing and sustainability. What we don't want is "ethical sourcing" to be used as a blanket statement. The leaders and knowledgeable practitioners in the field will be open about their sourcing and are willing to discuss their practices. The bottom line: Find a way of working with a level of accountability that leaves you at peace!

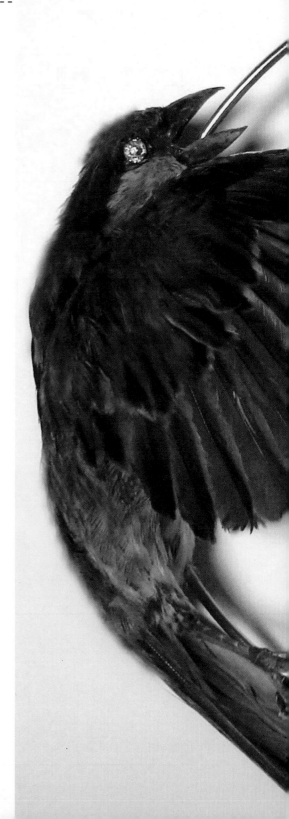

PLEASE DON'T BREAK THE LAW.

There is no way this book can cover all the laws for anyone who may ever read it, but we encourage you to look online, call your local wildlife officer or game warden, and know your laws before working on a specimen. Do not assume that just because it is dead, it's legal. Some states require roadkill collector permits for collecting roadkill, and some don't allow it at all. Some require that you obtain hunting licenses or other permits before you gain possession of certain animals. A frequently overlooked American law is the Migratory Bird Treaty Act, which makes the possession and sale of anything other than English Sparrows, European Starlings, and feral pigeons illegal. Game birds can be taken, but working on those birds requires permits, and even with a permit, they can't be sold. Most domestic birds are ok so long as you have proof of sale/domesticity. There is no clear wording here for antiques, and many times they fall into a gray area depending on who you speak with. That blue jay that flew into your window singing "please mount me" is STILL ILLEGAL.

CHAPTER 3
STUFF YOU SHOULD KNOW

Throughout this book, you may notice some words used, and you may not know what they mean. Or you may have thought you knew what they meant, only to discover that they have an entirely different meaning in context! This vocabulary will help you get a better understanding of what we are talking about in the tutorials, and it will help you prepare a shopping list when you're ready to buy tools and supplies.

TAXIDERMY 101

PELT OR HIDE – The skin of an animal with the fur intact.

SKINNING – The act of removing the pelt from an animal.

FLESHING – The act of scraping fat and any remaining muscle off of the skin (some people call it "defleshing").

MOUNTING – The proper verb for taxidermy (despite this book's title, please do not say "stuffing" unless you are talking about a turkey or peppers).

SPLITTING – The process in which a fleshy area is delicately sliced into, filleted open, and often thinned.

TURNING – The process in which ears are delicately opened up and inverted.

RELIEF CUT – An incision made to help open up tight areas on the skin, usually on legs or the head.

CARCASS – What is left of the animal when the skin is removed. There is always a thin but fairly sturdy membrane on the carcass that holds all of the organs, muscle, tissue, and everything else together like a clean little package. When you

Carcass

cut into this membrane, or if it receives any trauma, the carcass can come apart. (That's when the guts spill out and things get stinky.)

TAXI OR TAXIING – The act of moving the skin. As previously mentioned, taxidermy comes from the Greek for "arranging skin." So when you hear us say "taxi the skin" or "taxiing the skin" it means to move and arrange the skin on the form.

FIELD CARE AND DRESSING – The field refers to the outdoors in which your specimen is collected, and field care refers to how the animal is cared for after it is harvested and before it gets to the taxidermist. Depending on the animal, you'll need to skin it, clean it, and carefully handle and store it to keep its fur and feathers in good shape. It is also the process of cleaning up hunted animals in order to harvest safe meat by cleanly removing the undesirable organs (like ones that contain poop). Removing the organs also speeds up the loss of body heat and discourages bacteria growth.

PRESERVATION

SALTING – Applying salt to a raw skin in order to dry it out, halt bacterial growth, and set the hair. Salted skins are stored before they are further processed for tanning.

PICKLE – An acidic bath that prepares the skin for tanning.

TANNING – The process of chemically preserving the skin so that it will not rot. Tanning permanently alters the chemical composition of a skin, making it stable and long-lasting. Other than taxidermy, tanning is used for leather, fur, other animal

hide products in furniture and fashion, and more applications requiring preserved skin.

DRY TAN – A tan that comes back from the tannery as a flexible, dry skin and that can be stored on a shelf. You will need to rehydrate a dry tan, usually in a soak of salt water, but your tannery will send specific directions based on the type of tan that they use.

WET TAN – A tan that comes back from the tannery as a wet, flexible skin and that must be stored in a freezer until it is ready for mounting. Most home tanning kits produce wet tans.

DRY PRESERVE (DP) – A preservative powder dusted onto the skin in order to dry it out, discourage insect infestations, and inhibit decomposition. DP is mainly used for small mammals or thin-skinned birds. Some people use borax, while others use a dry preserve powder from a taxidermy supply company.

BORAX – Where would we be without borax? One of the most useful chemicals in taxidermy, the history of borax hints at unwritten stories about ancient preservation. Indigenous Americans living in the naturally occurring borax mines and flats of California and Nevada used the powdered crystals to dry and preserve skins and feathers way before the colonists arrived. Borax was also discovered in the dry lake beds of Tibet and eventually traveled west on the Silk Road. The word borax is from the Arabic word *būraq* (which means white), although it is also close to a Middle Persian word *bwrk*, which was used to describe another cleaning agent. Either way, the stuff worked, and word spread about the magical white powder. In the late nineteenth century, Francis Marion Smith, an American miner

and businessman based on the west coast, started the Pacific Coast Borax Company and began to market and popularize a large variety of household and industrial uses. Since he needed to use twenty mules to haul the mineral out of the deserts, the 20 Mule Team brand was born and is still seen on boxes today.

MUMMIFYING – Removing the organs, cleaning, and washing a critter before drying it out, essentially turning it into very dry piece of jerky.

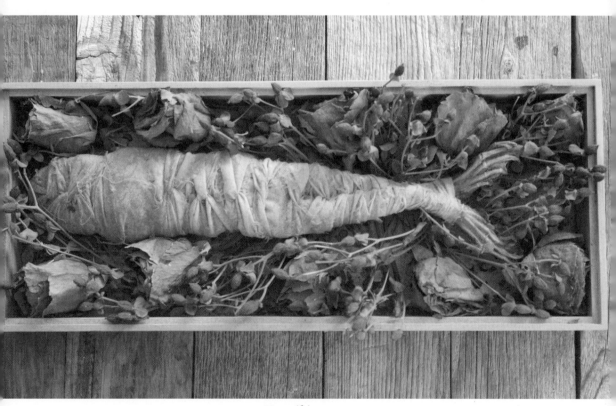

Mummifying

FORMS

LIFE-SIZE – a pelt or taxidermy mount displaying the whole animal.

HALF LIFE-SIZE – a pelt or taxidermy mount displaying half of the whole animal (such as just the front half, or more humorously, just the back half).

SHOULDER MOUNT – When you think of a head on a plaque on a wall, you're likely thinking of a shoulder mount. The head to the shoulder area of an animal.

WRAPPED BODY – One of the oldest ways of making a form, using wood wool compressed and wrapped tightly with thread or twine around a wire armature.

CARCASS CAST – Making a mold from the carcass of your animal in order to cast it in another material.

SKULLS, BONES, AND MORE

BEETLE CLEANED – Refers to skulls that have been cleaned by beetles, but not yet degreased or whitened.

RAW OR GREEN SKULLS – Skulls that have had the skin removed, but still have meat, tissue, tongue, brain, or eyes intact.

EURO MOUNT OR EUROPEAN MOUNT – A cleaned skull that hangs from a wall, usually on a plaque, and usually done with deer, elk, and other antlered animals.

Beetle cleaning

ANTLER – True bone that is grown as an extension of the skull from a pedicle, a bony platform. Antlers are found mostly in males of the cervid, a.k.a. deer, species, although female reindeer have antlers. Usually the bigger the antlers, the better the chance of mating. Bucks also use their racks to fight other males. Antlers are shed and grown each year, when the pedicle breaks free.

ANTLER IN VELVET – A thin fuzzy layer of flesh that provides blood to the antlers while they are growing. This layer is

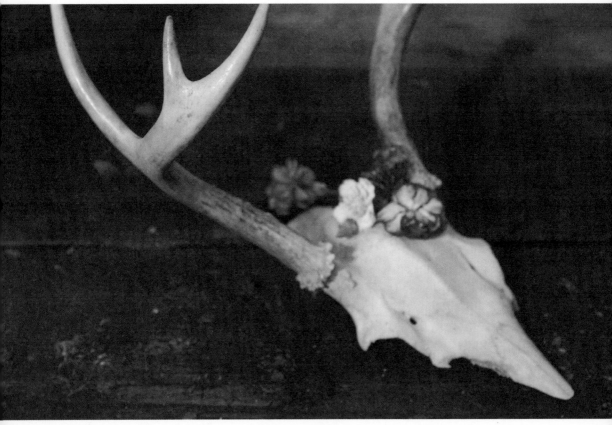

Antler

rubbed off against a tree or other hard surface once the antlers are fully grown.

HORN – A two-part structure with a bone interior and an exterior sheath grown from specialized follicles. Horns are never shed, and they grow throughout the animal's life (the exceptions here are pronghorns, which shed and regrow the exterior sheath yearly). If a horn tip breaks, it does not grow back in the animal's lifetime.

TUSK – Essentially very long teeth that grow continually and extend way beyond the mouth or other part. Other than elephants, tusked animals include the warthog, walrus, and the narwhal.

PINFEATHER OR BLOOD FEATHER – An immature, new, or developing feather being grown on a young bird or replacing a molted feather on an adult bird. Pinfeathers look like little plastic feather shafts, but they have blood flowing through them, so don't mess with them on living birds because this can hurt them and make them bleed. On deceased birds, pinfeathers tend to fall out since they are not fully developed or securely attached to the skin.

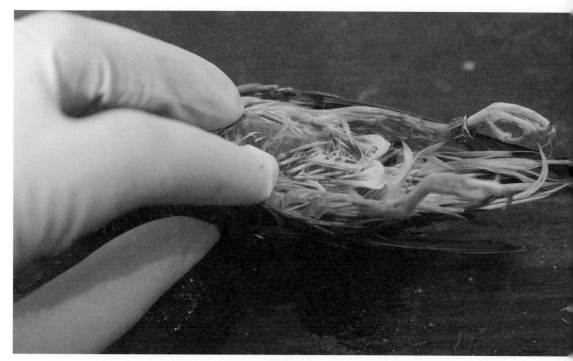

Pinfeathers

COMMON PROBLEMS

SLIPPING OR SLIPPAGE – The most significant sign of slippage is hair loss, but keep in mind that it is not the hairs themselves that are popping out the follicles, but the top layer of the epidermis that is literally slipping off. Slippage can be caused by a number of things—bacterial activity that compromises the skin, excessive heat applied to the skin, excessive handling of sensitive skins or sensitive areas of skin, or the overworking of skins. Once slippage has started, it can't be reversed. To prevent or at least discourage slippage while working, some taxidermists soak the skin in denatured alcohol or specialized chemicals like Stop Rot or Stop Slip. Proper storage of a skin will also help in preventing slip. Some skins, such as that of a fox, are more delicate and prone to slippage than others.

DRUMMING – When the skin doesn't adhere to or dry up against a form and creates wrinkles or an uneven texture. Thin- and short-haired animals will show drumming more than thicker-haired animals, which makes them more challenging to work on.

Drumming

FREEZER BURN – This is the same thing that happens to your sad old pizzas. Sometimes it can be fixed by injecting water or other chemicals into the area and letting it expand and loosen the tissue, but certain cases, especially with hair or feather loss, are irreversible.

SUPPLIES AND TOOLS

Scalpels

Scissors and snips

Calipers

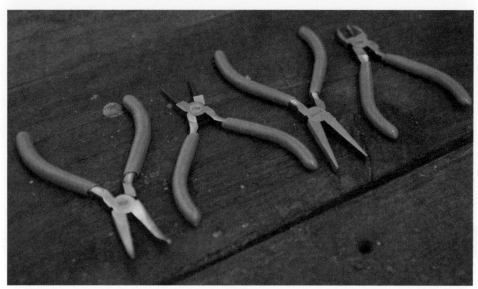

Pliers

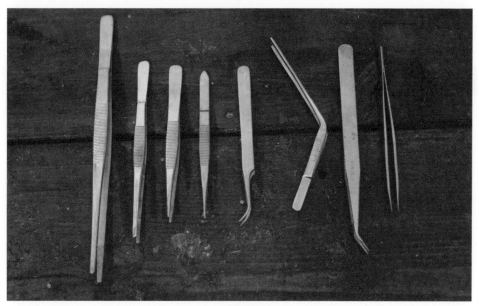

Tweezers

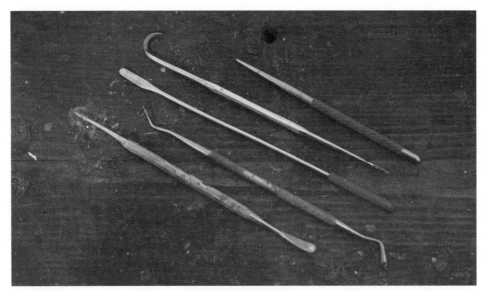

Modeling tools and picks

Fleshing beams

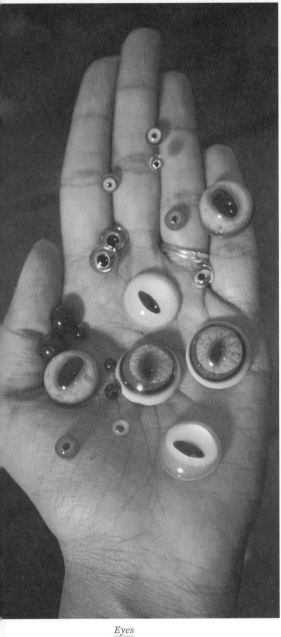

Eyes

Needles

Tail stripper

Scraper for fleshing

Skife knife

Blow-dryer

Wire brushes

Ear opener

Paints

Paintbrushes

FREQUENTLY ASKED QUESTIONS

What do I do if I want to split a project between two days?
Between most steps in the skinning and fleshing process, you can put the skin in the freezer. Beware of too much re-freezing and thawing though, as it may stress some skins or cause slipping. For skins in the pickle, most can stay for quite some time as long as the pH is maintained.

How can I tell if a taxidermist is any good?
Take a look at their work and see if you like it! Also ask them what associations they are a part of, as state and local associations have standards and rules for membership (like following laws, codes of conduct, etc.). Also ask to see what awards and honors they have won. A good taxidermist will be happy, and even proud, to share this information with you. Although some taxidermists like to keep parts of their processes secret, they will be happy to answer most questions you have regarding quality of work.

Do I need to tan bird skin?
Some people do and some people don't, based on personal preference and how they were trained, and what they feel works best for them. There are museums and established institutions with bird specimens that have no preservatives on them, ones with dry preserved skins, and ones with tanned skins. Some species with extremely thick skin, like rhea and ostrich, do get tanned. (They even make fashion leather goods out of these skins.)

How do I maintain my pieces and prevent a moth or bug infestation?
Taxidermy is best stored in a cool, dry place away from direct sunlight and out of the reach of pets. Some pets see taxidermy

as a toy or are very curious about the fur and feathers, so they lick, bite, or attack specimens. Sunlight, heat, and humidity are all detrimental to taxidermy. Be sure to dust and clean your pieces as often as you deep-clean your home. You can carefully vacuum, use a clean, soft makeup brush, or use a blow-dryer to remove dust. It is easier to dust a little bit and often rather than have to remove a ton of dust at once. By cleaning regularly, you'll also be able to monitor for bug damage.

Thorough fleshing and proper preservation, using dry preserve or a tan, is the first step to preventing bugs. However, as with a fur coat or wool jacket, bugs can be attracted to and eat the hair, feathers, and fur on taxidermy. Arsenic was one of the most effective and longest-lasting bug-proofers, but due to its negative effects on human and environmental health, it was phased out of use and made illegal in many industries where it was previously used—including taxidermy and tanning. There are no chemicals currently on the market that are as long-lasting in their bug deterrence as arsenic was, so you'll have to care for your mounts and the environment they are in. In addition to cleaning your mounts and your home, you can also purchase pheromone-based moth traps that attract and kill the males, making sure they don't reproduce. The tiny larva, not the flying moths or dermestids, are the ones that do the most eating, so they are the ones to look out for. If you see a chalky grayish-white dust and missing hair, that is a sign of bug or moth damage. There are also products like Mount Medix that kill pests and are formulated for the taxidermy industry. Another good idea is to have an exterminator come to your home, even just once a year, to take care of any problems.

To kill bugs on existing mounts, especially when bringing home vintage mounts, you can use a number of methods. The most effective is the most toxic—suffocating the bugs in an air-

tight container and using a permethrin-based bug spray. This can be done in a big storage box with a tight lid or a bag that you seal off, but be careful when you use the spray—spray into the container and don't breathe it in, and wear a protective mask or respirator if needed. Some also say freezing kills pests, but some bugs just go dormant in this phase (at least in regular freezers—a medical grade freezer may be a different story). If you have a serious bug problem, call in the professionals—exterminators and taxidermists. Their experience, knowledge, and access to chemicals not available to individuals make them the pros.

Maintaining a collection of taxidermy, even if it is just one or two pieces, takes a bit more work than most people think, but its totally worth being able to make and have cool stuff.

What are the rules about antique taxidermy of protected species?

In most cases, the new rules still apply to old pieces. It is best to call your local wildlife offices and ask. Most states do not allow these items to leave the state. If you are unsure of a vintage piece, and the seller can't ensure legality, it is best to leave it alone or suggest the donation of it to a museum that can legally have it.

HELP! It's slipping!!!!?!

Things slip! If a soak in denatured alcohol, Stop Rot, or Stop Slip doesn't work, chances are the specimen was too far gone. Find a creative way to use it (half life-size mount, fantasy mount, etc.) and learn from the experience.

Where can I meet other taxidermists?

At your state association. Attending workshops there and competing is a great way to meet other taxidermists. Even if you're a rogue taxidermist, it is really valuable to put yourself out

there and meet others doing traditional taxidermy. We are all united by a love of wildlife and art. There are very few industries where the top masters in their field share their knowledge so openly with total newbies. You can only get so far by creating in a bubble, and attending shows will make your work better. Online groups and message boards are also great tools. Taxidermy.net, one of the first taxidermy websites, is an endless source of knowledge and information, and it is constantly updated. You can meet other artists in your area there. Social media sites like Facebook, Twitter, and Instagram also have a lot of taxidermy and taxidermy art interest groups you can join.

Where can I get specimens?
Other than legally collecting animals from the outdoors (whether through legal hunting and trapping or legal road kill collection), you can put the word out and soon find yourself in a sea of dead things. Tell your friends about your awesome new hobby. Reach out to farms and breeders, and politely ask if they would be willing to sell you any casualties. You can also check online taxidermy interest forums and ask others in your association if you are looking for something. Other than legality, the most important thing to keep in mind when inquiring about purchasing specimens is to be polite. Death is a sensitive subject, even for breeders and farmers that see a number of casualties, and nobody wants to feel like you are asking for things for free.

Oh crap! I put a hole in it! How do I repair it?
It is totally normal to make holes while skinning, fleshing, and handling animals, and the more experienced you get, the less this will happen. Also think of a traditional taxidermist working with hunted and trapped animals—part of their process

involves fixing holes from shots and trap marks and damage. Carefully fix holes by using hidden and invisible stitches, being sure to line up the fur and feather patterns. You can even put the skin on the form to see how the damaged area goes together before sewing it closed. For small holes and holes on delicate skins, repairs can be made by adding a dryer sheet as reinforcement and sewing, or even using the dryer sheet in combination with super glue.

How do I stay safe while working with dead stuff?

DO NOT skimp on safety! Use quality gloves to minimize contact with pathogens and nasties. Be wary of known disease vectors (for example, working with domestic or feeder rats is fine, but working with wild ones that are known to carry viruses is not). Store frozen specimens away from food. (We strongly suggest a separate freezer.) Freezing may kill certain agents, but it is not a cure-all. Thoroughly clean work surfaces with a strong disinfectant. When sanding or drilling dusty stuff such as foam or bone, wear a good respirator and goggles. Follow the manufacturer's precautions and material safety data sheet (MSDS) for all chemicals used.

CHAPTER 4
REFERENCE, REFERENCE, REFERENCE. AND REFERENCE.

You can tell a good taxidermist from a great one by looking around their shop. A great taxidermist will surround themselves with references for what the final product should look like: photos, casts, drawings, sculptures, etc. With modern technology it is really easy to find great references or make your own! Most digital cameras and phones can now take high-quality images. Go out and get to your local zoo or wildlife rescue to snap some pics. Instead of mindlessly scrolling social media during downtime, search for images of some of the animals you would like to work on. Make folders on your computer and print out the best images or your favorite ones. Tack them on to your walls like we did in the '90s with band posters. Become that crazy ex who stalks all your online accounts, and try to find pictures from every angle, expression, and age. You want to surround yourself with all the information you can so that if you are questioning your ear placement, for instance, you can look at your pictures and see where they should sit. It may sound really creepy, stalkerish, or obsessive, but references are insanely important. Always use them. Even if it is an animal you have worked on countless times, look at your ref-

erences. We can't overstate that the keys to accuracy in a mount are references and observation. We would be writing *War and Peace* if we were to go into full anatomic, kinetic, and biological detail for every animal that one may ever mount, but we will give you a guide to finding and maintaining a good reference photo library.

THE ZOO (OR YOUR BACKYARD)

A trip to your local zoo can be very rewarding for reference collecting. If you cannot find a specific pose online, try snapping a picture yourself. It might feel weird going to a zoo, since you probably have not gone to one since you were a kid, but get past that and go! You may even want to plan a day trip to a larger zoo with a larger collection. Going on off-days or during

bad weather will limit your run-ins with crowds—and it may increase your chances of seeing more active animals.

Alternatively, you can just stay home and observe the wild animals in your own backyard. Or even the ones clawing at your furniture.

DEATH MASKS

Death masks and carcass casts are also great tools for reference. Some work needs to be done to ensure anatomical accuracy, since dead tissue is limp and will need to be plumped up. Injecting the eyes or replacing them with glass ones will allow for an accurate portrayal of eye depth and placement on your casting. You may need to inject the cheeks or nose too, depending on the condition of your specimen. Go slow, though; if you add too much, your specimen will look like one of those bad plastic surgery jobs. You will need to create a collar around the face of your animal to limit any material drips onto the rest of the fur. Use petroleum jelly to slick back the fur and as a mold release.

You can use plaster or alginate to make your first negative mold. Mix up either of the two and carefully apply it evenly on the animals face. Once cured, gently pull your specimen's face out of your mold. If plaster was used you will want to either pour fiberglass resin or body-filling putty inside, then carefully break off the plaster shell and wash off any remaining plaster. For alginate, cast immediately, since it will start to break down, which will interfere with casting or dry out and crack. You can use plaster to cast your positive mold. Now you have an exact replica of your specimen that can be used for study and reference when mounting. By looking at your reference casts and using your measurements, creating a more lifelike mount is possible. Casting the side of a whole animal is another great idea, as

it will show you the animal's posture as well as where the joints attach on the body.

MEASUREMENTS

In order to retain anatomical accuracy, it's best to take some external measurements before jumping right into skinning.

Skinning is exciting and fun, but taking a minute for some measurements will save you countless headaches and limit your room for error. The more you take, the more exact your final product will be, but for now let's start with the basics.

Your first measurement is from the tip of your specimen's nose to the front corner of the eye. Then measure around the base of the head/top of the neck. Next, wrap your measuring tape around the widest part of the belly for a circumference. Finally, measure from the tip of the nose to the base or top of the tail. These measurements will help you create your body or pick out a commercial form.

Any time you have the opportunity to work with a whole animal, use it as an opportunity to compile important info. Whenever you get a whole animal, lay it on a plain, non-busy, or boring background and take pictures. Take pictures of the toes, face, ears, nose, beak, eyes, fur, feathers, and any other significant detail.

SKETCHES

You do not have to be an artist to be a great taxidermist. It certainly can help, but it is not a necessity. There are world-class taxidermists who can't draw to save their lives. When working on something new, try to sketch it to the best of your ability. Mark on your sketch where your measurements were taken, and note anything else you may have observed. Be sure to measure your eyeballs too! Many commercial forms recommend a specific eye size, but it really comes down to each specific specimen. Maybe your specimen had some trauma on one side; mark it so that you can plan a way to conceal it. Maybe the eyes on your animal were a slightly different color than what is normally seen. Any little detail is worth noting.

DEVELOPING YOUR EYE

Understanding how the body works from the inside out helps
when creating any taxidermy piece. Something may look right
from the outside, whereas inside of the body it may not be pos-
sible. A deer can move its ears around like little satellite dishes,
going off in any which direction. Your pose might look decent
from the outside, but knowing the internal anatomy of where
the ear attaches to the skull is very important. Small details
like this really make or break your mounts. You have to double-
check every step of the way. When putting something together,
stop and think, "Is this possible?" Your friends and family
may think this is the beginning of your downward spiral into
becoming a weirdo, but take photos of skinned carcasses. Move
the limbs around in their sockets and up and down to see the
body's natural restrictions.

CHAPTER 5
MAMMALS

YOUR FIRST PROJECT: A SMALL MAMMAL

This tutorial can be used for any mammal that is no larger than a squirrel. If squirrels aren't your thing, try rats, rabbits, or chipmunks. Please freeze your specimen first, as it helps toughen up the tissues and will help kill some nasty mites, bugs, or parasites your critter could be carrying. Some people like to thaw their specimens in denatured alcohol, though some prefer to skin the animal first and then put only the skin into alcohol. This helps toughen the tissue and prevents slippage to a certain extent. This is not a cure-all, but it does help! For this tutorial we will be dorsal skinning our specimen. Dorsal skinning is ideal for beginners since it is easy to do, requires little sewing later on, and helps beginners avoid cutting into the abdomen (the guts and gooey grossness) by accident. Other skinning methods are explained at the end of this chapter.

PREPARATIONS

Your first step is to measure the animal. Take a measurement from the tip of the nose to the front corner of the eye, then around the widest part of the belly, and then from the tip of the nose to the base of the tail. You can take other measure-

ments too, such as length of limbs, etc. Thaw the animal half-way in a fridge or cool water, then place the animal flat on its belly. If you don't want to see any poop, you can also pack the anus with some cotton.

SKINNING

When approaching skinning, think about the hide/fur as a bodysuit you are unzipping and removing from the carcass. The carcass will come out as one whole piece, relatively clean and held together by a thin membrane. Part the fur from behind the base of the head down to about a half inch or so above the base of the tail. To start your incision, hold the scalpel upside down and make a puncture (Figure 1). Then slide the scalpel through the underside of the skin, gently wiggling it upwards if you need help cutting through the skin. You can cut from above, but it can be more challenging as, catch fur and cause an uneven seam line later.

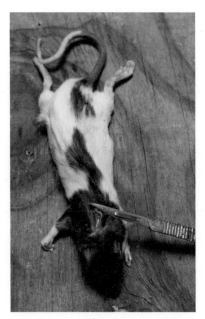

Figure 1

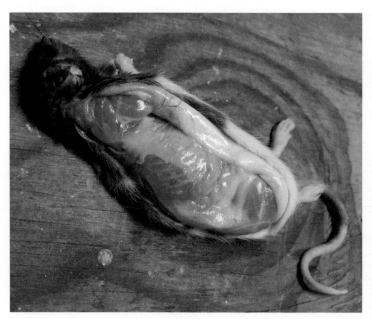

Figure 2

Once you have your incision, start peeling the skin down
to around the belly and the limbs (Figure 2). If you have any
trouble at all, carefully touch your scalpel blade to the white
line of connective tissue that appears with a little amount of
pressure being applied from pulling the skin back. You can also
use borax to act as an abrasive to really help remove the skin
from the carcass.

When you get down to the belly, you can slide your hand in
between the skin and the carcass, cradling the belly until you are
able to push your hand through to the other side (Figure 3). Next
up are the limbs. The front paws can be a little tricky since they
have fattier paw pads and require you to cut into them, releas-
ing this tissue before you can go down to the toes on them.
Grab the feet from the outside (we like to grab at the hock) and
push the limb into the carcass. Then slide your finger between
the skin and meat under the knee joint until your finger pushes

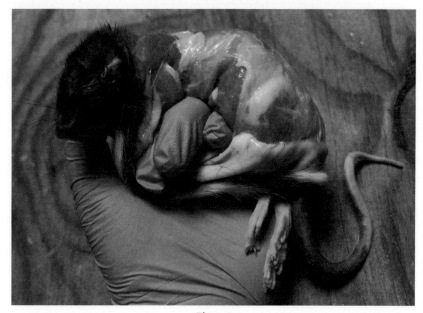

Figure 3

through (Figure 4). Finger wiggling and borax can help here too. Then gently work the skin down to the toes (Figure 5). You don't need to skin that far on smaller mammals.

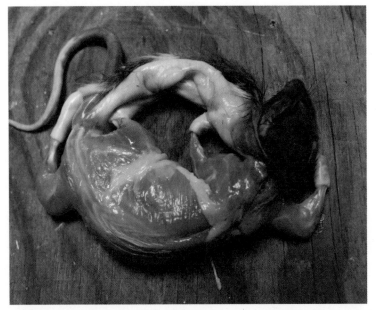

Figure 4

Figure 5

Now on to the booty. You need to carefully cut through the genital area, loosening up that skin and the anus. If you are lucky enough to have a male rat or squirrel, you will need to pop the balls inside out into the carcass to remove the internal testes. You will most definitely see the balls! Rats especially are not shy in that department. For the tail, we are going to use tube skinning. You can use your thumb and index fingers, a tail stripper, or a plastic clothespin for this. Work the skin down the tail a little from the inside and cradle the tailbone between your index finger and thumb (Figure 6). Your index finger is for support, and your thumb is supplying pressure. Use the tip of your thumb and the nail to work the skin down off of the bone. It will fight for about a third to half of the way, and then it will just slide off like a sock (Figure 7).

Figure 6

Figure 7

Once at the base of the head you will want to be very careful so that you can keep all the important facial details on your skin—earbutts (the base of the ear), eyelids, tear ducts, lips, and nose (Figure 8). This is very much like removing a mask. The best thing to do is to reference where you are on the head by reinverting the head and placing your index finger down into the ear. Then invert the skin again, you should be able to now accurately gauge where the earbutt is with your finger down in there. Cut into it, close to the skull, until you see it release, at which point the ear canal will come into view (Figure 9).

Work your way a little further down the face until you reach the eyes, put your finger in the eye from the outside, and gently tug the skin away from the skull. You should be able to see a white line appear across the eye. Touch the blade to this and release the eyelids from the eyes. Be sure to stay close to the skull in order to get the tear duct and not create a hole (Figure 10). Work your way down the face a bit more and

Figure 8

Figure 9

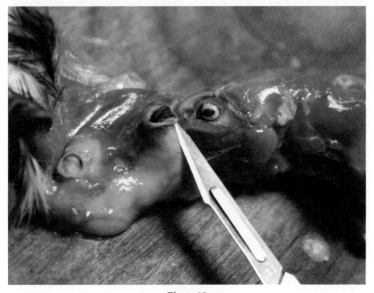

Figure 10

begin to cut into the skull right in front of the cheek meat. This releases the inner cheek and lip. Then follow the lower jaw around with your blade, releasing the skin (Figure 11). Then pull that inner cheek skin away from the upper lip and cut in between the skull and the skin, up until you get to the tip of the skull. You should be able to see or feel where the skull ends and

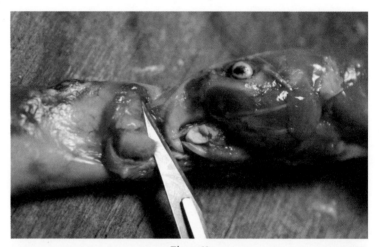

Figure 11

Figure 12

the cartilage begins. Cut as close to the skull as you can, leaving as much cartilage on the skin as you can (Figure 12).

Congrats! You have just skinned your first animal (Figure 13)! Notice how our carcass is intact, and there were no waterworks or explosions. The more you skin, the faster you'll get.

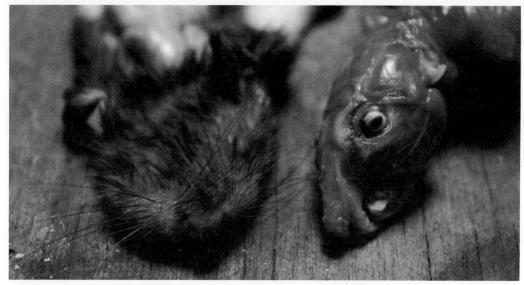

Figure 13

FLESHING

Fleshing—the removal of any fat, connective tissue, or residual meat from the skin—is THE most important step in the process. The removal of these globs is imperative in the penetration of a tan or effectiveness of a dry preservative. It is worth taking your time with this step. Put on your favorite album or podcast and just go to town. You can gently pull the flesh off using your hands and a dry paper towel, or by scraping with your blade, or by using a wire brush and borax (or fingers and borax). It helps to flesh over a beam, dowel, or horn of some sort in order

to get some leverage over the skin. Believe it or not, having the right amount of tautness prevents you from applying too much pressure and causing holes. You will know you are done when the skin is a clean, whitish color with nothing that feels like boogers attached to it. On some animals, the skin takes on a blueish-white shade (Figure 14). The left side in the figure below is clean; the right is unfleshed.

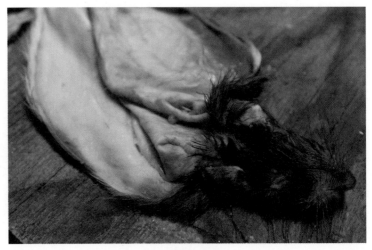

Figure 14

At this point we are soaking the skin in alcohol to help tighten the fur follicles and clean any blood off the fur. This step also makes it easier to peel any connective tissue or flesh off of your skin. If there is any stubborn blood, you may need to wash in some room-temperature water and some dish soap. You can continue fleshing after washing.

TURN AND SPLIT

For squirrels and rabbits, you will need to split their ears. Between the skin and the earbutt there should be a notice-

able line, which you can gently slice over, in between the outer-back ear skin and the inner ear cartilage (Figure 15). You can also insert small rounded tools such as brushes into the ear to help open them up (Figure 16). This is a very delicate process, so go slow. It is best to not move the tool, but rather slide the ear around over the tool while it is in there. Some people also like to use their fingers for it, especially for bunnies or larger things.

We will need to split the lips and eyelids as well. This part is hard to describe: Think "extreme duck-face" (Figure 17). Essentially, you are unrolling that inner lip skin. The lips will appear fat and fleshy from the inside, so you will want to cut into them, opening up and unrolling them so that the lip line feels relatively flat. The eyelids are a similar process, but there is not much skin to split.

PRESERVATION

You have a few options for preserving the skin. You can tan the skin by using a commercial concoction from a supply company, dry pre-

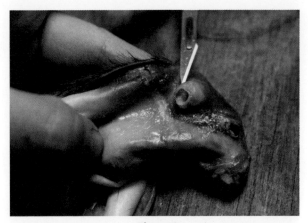

Figure 15

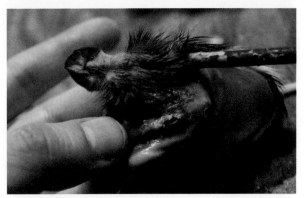

Figure 16

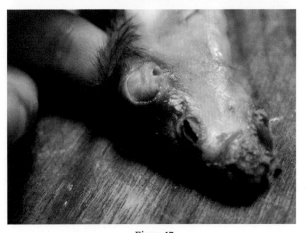

Figure 17

serve it with a powder mix from a supplier, or soak the skin in alcohol for at least 15–20 minutes to overnight and use borax. You can use the alcohol and borax methods as long as the skin is thoroughly fleshed and is thinned down. Tanning the skin is the best method since it ensures that the chemicals penetrate down into the tissue completely, but as long as it is fleshed and thinned, dry preserve or borax is fine (Figure 18). Be aware though that by using dry preserve or borax, your skin will have little to no stretch. A properly tanned hide will have more stretch to it, and it will be easier to work with as a result.

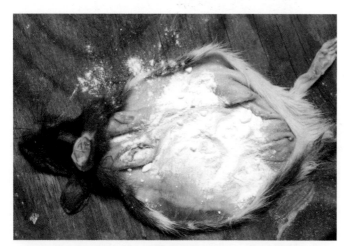

Figure 18

ASSEMBLY

Once the pelt is preserved and prepped, you will either make a form or use a commercial one. If you choose to buy a form with close measurements, smaller is always better, as you can modify it afterwards. Most commercial forms need some sort of alteration; just like people, no two animals are alike. A commercial urethane foam form will need to be prepped. Rough it up using a stout rougher or sandpaper, then carve out slots under each of

Figure 19

the limbs where there is a fold, and do the same for the lip line, nostrils, earbutts, and eyes (Figure 19). Ears should be filled with dyed two-part epoxy clay or liners so they remain upright once dried (Figure 20). Once everything is prepped, you can test fit your skin to see if anything needs alterations.

You'll notice that we use clay to sculpt the finer details (Figure 21). Not only does this add volume and roundness to the form, it gives the hide something to adhere to as it dries. While working with clay, you may want to keep a wet paper towel or a water mister handy if you notice the clay getting too hard or cracking as you work with it. After selecting an appropriate eye (bubble eyes or black glass beads work fine for most rodents), fill the eye and ear holes you carved out with clay and install the eyes, paying special attention to symmetry and the amount of bulge (Figure 22). Use small logs of clay to create the upper and lower eyelids—it is incredible how even the most subtle changes of diameter or angle can completely alter the expression of your piece, so be sure to use plenty

Figure 20

Figure 21

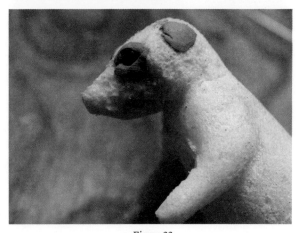

Figure 22

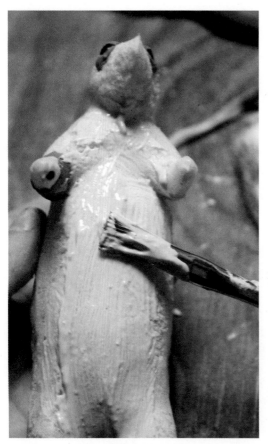

Figure 23

of reference photos—and patience! Then add a little clay on the nose and sculpt the upper and lower lip lines. Remember that unrolled lip and eye skin? We will be tucking that into the form and clay later! Earliners will be made to add shape and structure to the split ears; hard plastic, body-filling putty, and epoxy sculpting clay all work. The other clay work needed is in the nose and in the feet. Roll thin logs of clay and be sure to pack them all the way down by the toes.

If you are using a hard foam form, you will want to lightly apply hide paste to the face and belly area (Figure 23). Hide paste adheres the hide to the form and prevents problems like drumming, wrinkling, and unwanted shrinkage. Do not cover the whole form, since it will only make a mess and slide all over once you put your skin on the form. A helpful way to apply hide paste is using a caulk gun (or disposable plastic wide-mouth syringe), tucking the tip between the skin and the form. Wrapped forms do not really need the adhesive, but you can apply a little as needed.

Slide the skin on your form face first, then work each paw down onto the form, going from front to back. If skinning was taking the bodysuit off, this is gracefully putting it back on! We are "taxiing" the "dermy" now and telling the skin where to go, where we want it to fold, and paying attention to the fur patterns. Keep taxiing the skin down to get the joints where they need to go. Before pulling the skin around the torso, be

sure to install the sculpted tail by carefully sliding it into the empty skin, then securing it in the appropriate place on your torso. For the tail, you can use a tapered red or pink pipe cleaner with a little caulk on the end as a lubricant and filler (Figure 24). Make a small indent by the base of the spine for the pipe cleaner end to sit in, and add some clay around it to make a thicker tail base (Figure 25).

Once the skin is on and once everything is in place and close to where it belongs, you can start sewing up your incision. Select an appropriate needle and thread for your critter (thicker skins mean heavier needles/thicker thread, while thinner ones go smaller—see the thread and needle guide). Thread the needle so the thread is doubled up, and knot the end. The baseball stitch is the easiest and most commonly used. The baseball stitch is done by inserting the needle through the fleshy side of the skin, pulling it through, then passing it to the other side—only stick the needle through the underside of the skin (Figure 26).

No matter which stitch you use,

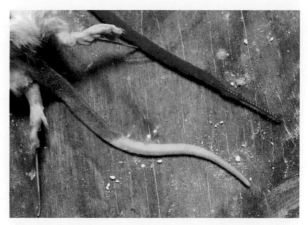

Figure 24

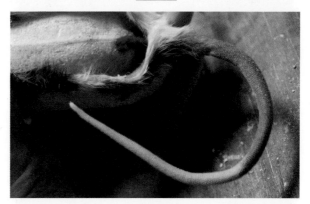

Figure 25

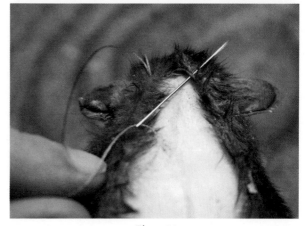

Figure 26

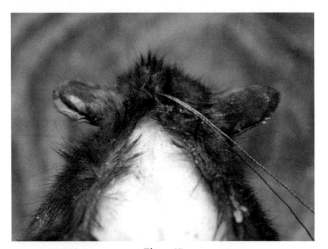

Figure 27

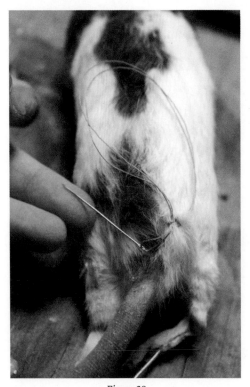

Figure 28

take your time, do your stitches relatively close together, and keep the fur out of the stitches. Most people prefer to sew from the head end of the incision to the tail end of the incision, as this encourages the fur and hide to lay flatter and more naturally (yay gravity!) and because the finishing knots can be better hidden by the butt. Pull the skin tight as you go, and make sure not to pull the thread too hard, as this can cause tears in the skin (Figure 27). Once you are all sewn up, tie off a few knots using the needle knot method—take a stitch, and before you close it, pass the needle through the loop, then tighten (Figure 28). Then take a deep breath, because now even more magic will begin!

For the head, slide the skin into place, lining up the ears, eyes, nose, and lip line. Using a modeling tool or even a toothpick will set the facial features. Pull the eyes into place, loosely tuck the unrolled skin, and begin shaping the lids (Figure 29). You will notice your critter's expressions coming back to life, but please wait to set the rest of the face before getting too fiddly here! For the ears, tuck the earbutts down into the clay we have placed on our form (Figure 30). It is a good idea to card the ears—meaning to

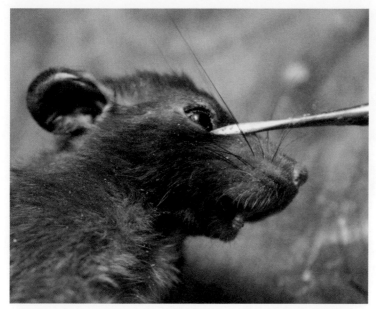

Figure 29

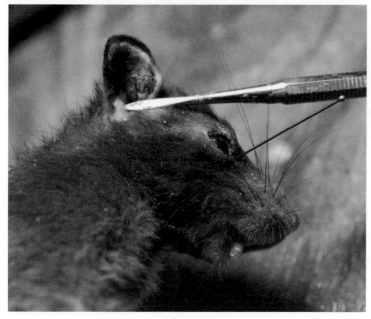

Figure 30

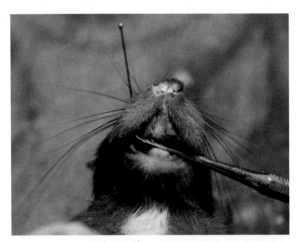

Figure 31

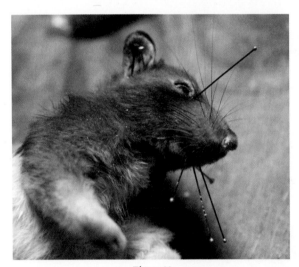

Figure 32

support them with wire mesh, tape, or cards—after they are set in place. Position the nose and then pull that excess lip skin and tuck it into the slits we made in the form (Figure 31). Duckface no more! Once the lips are tucked, use thin pins to pin them in place. The pins pass through that interior lip skin and sit just inside the lip line (Figure 32). Pins can be used in the nostrils too. Now go back to the eyes and finesse away, being sure to pay attention to your reference photos. Pins can be used in the corners of the eyes, again passing only through the interior skin. Be sure to carefully clean your eyes and remove any excess hide paste or clay.

For the body, tuck or push the armpits/groin areas into those slits we made into our form (Figure 33). Pay attention to your fur patterns and reference photos. The anus gets tucked in a manner similar to that used for the mouth (funny how that works!). After everything is pinned, it is time for grooming. A variety of brushes and a blow-dryer on low heat are helpful here.

As you are admiring your handiwork, keep in mind that your mount will be slowly drying (Figure 34). A cool, dry place is best. Dry time varies with the hide, size of animal, tanning

or preservation method used, and environmental factors. The hide is an organic material that has a mind of its own. Like a snake in a bag, it can move unexpectedly—so if you see something move out of place while drying, correct it. The pins and supports are there to keep things in place as they dry, so do not remove them until the skin and all other parts are totally hard and dry. Once dry, you may notice that some parts—such as the inner ears, nose, and bare parts of skin like the eyeline and lipline—have faded or changed color. This is totally normal. It just means that the tan or preservative has taken effect, and you can touch up these areas with paints as detailed in the chapter on finishing.

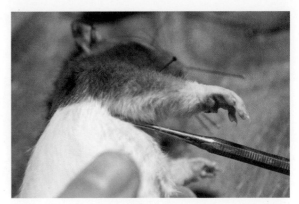

Figure 33

Figure 34

HOW TO SKIN A LARGER MAMMAL

Be sure to take your measurements (Figures 1, 2)!

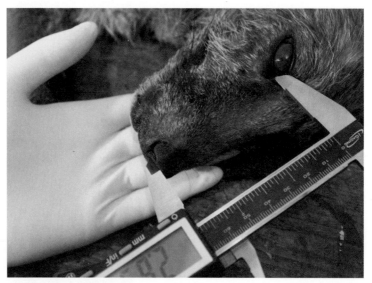

Figure 1

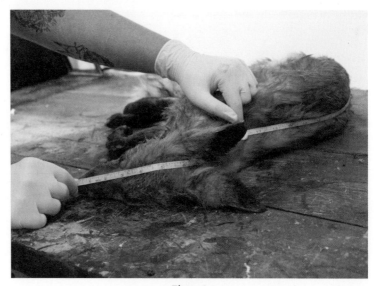

Figure 2

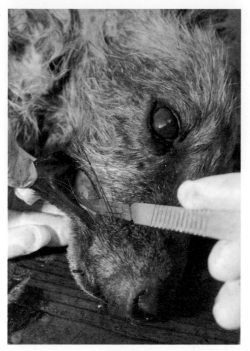

Figure 3

Figure 4

For larger mammals such as foxes, we like to skin and loosen the face first, then go down the body. You can fit the skulls of almost all predators through their mouth when skinning.

Separate the lip from the jawbone and begin cutting in between the skin and the teeth (Figure 3). Then continue down all around the lower jawbone and up around the upper lips (Figure 4). When you get to the nose, cut as close to the bone as you can, leaving as much of the nasal cartilage on the skin as possible (Figure 5). Now the skin is completely free (Figure 6).

Work your way up the muzzle toward the

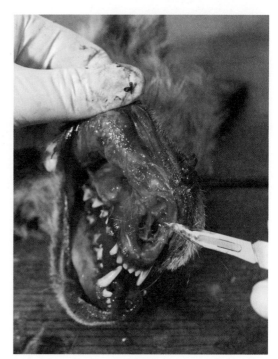

Figure 5

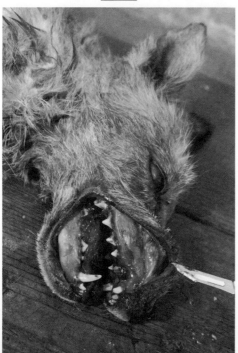

95

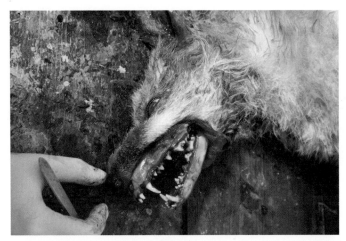

Figure 6

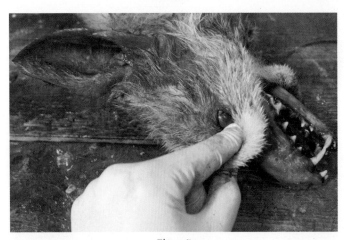

Figure 7

eyes. Once you get to the front of the eye, stick your finger in the eye socket from the outside and lift the skin upward (Figure 7) away from the skull as you carefully cut in between the eyeball and the skin. You should be able to see a white line appear across the eye; touch the blade to this line and release the eyelids from the eyes. Be sure to stay close to the skull in order to get the tear duct and not create a hole (Figure 8).

Now continue up the skull until you reach the ears (Figure 9). If you are not sure where you are, place your index finger down into the ear and wiggle it around. Doing this will help you feel where the earbutt connects to the skull. Cut into it at the base as close to the skull as you can until you see it release, at which point the ear canal will come into view (Figure 10).

Lay your specimen down flat and part the fur from behind the base of the head down to about a half-inch or so above the base of the tail. To start your incision, hold the scalpel upside down and make a puncture (Figure 11). Then slide the scalpel

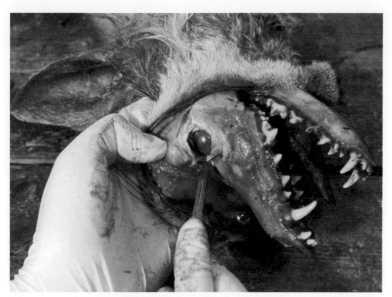

Figure 8

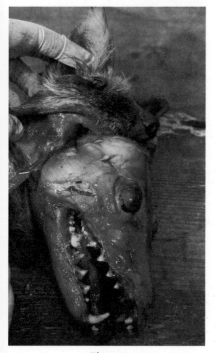

Figure 9

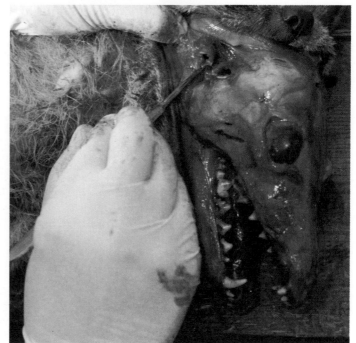

Figure 10

through the underside of the skin, gently wiggling it upwards if you need help cutting through the skin. Start peeling the skin down the back and sides then around the belly and the limbs (Figure 12).

Grab the feet from the outside and push the limb into the

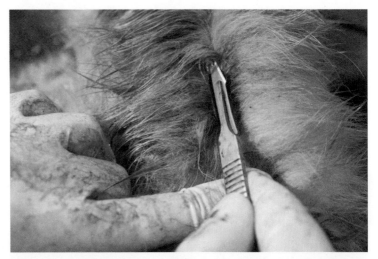

Figure 11

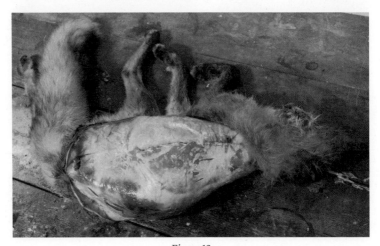

Figure 12

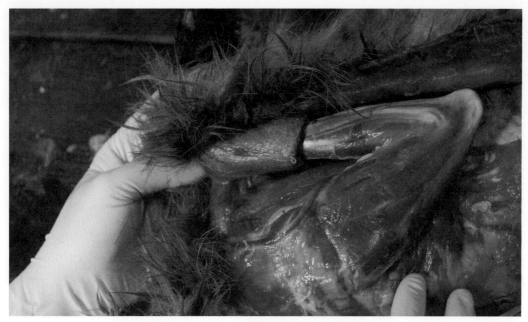

Figure 13

carcass (Figure 13). Then slide your finger between the skin and the meat under the knee joint until your finger pushes through. Getting the skin over the hock can be difficult, and a relief cut is often needed for most mammals.

Slit from the back of the hock down to right before the toe (Figure 14). Carefully part the skin along that incision and work out each toe to the last knuckle (Figure 15). If you are unable to remove that

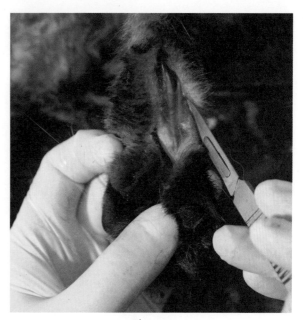

Figure 14

much from each toe, leave them in place. You can inject them later and they will just be a little shrunken when dried. The same process is done for the hind paws once you get to them (Figure 16).

On the underside and crotch area, you need to cut through

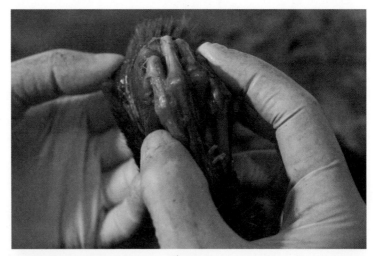

Figure 15

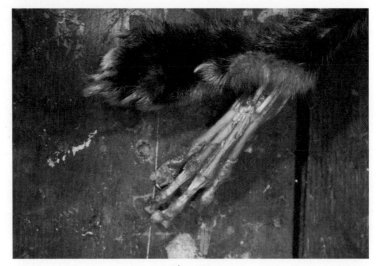

Figure 16

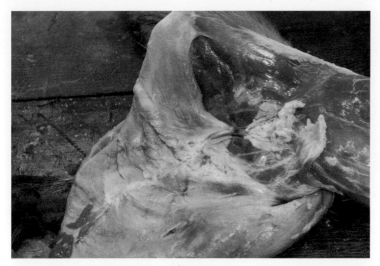

Figure 17

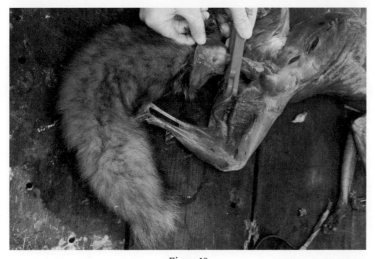

Figure 18

the genital area, loosening up that skin and the anus (Figure 17).
Differentiate between the tailbone and the anus—you need
to cut through the anal tract. For the tail, we are using a tail
stripper, although you can use your fingers like in the first small
mammal tutorial (Figure 18).

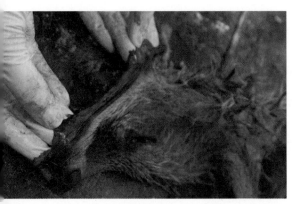

Figure 19

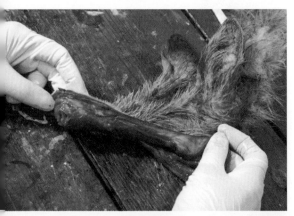

Figure 20

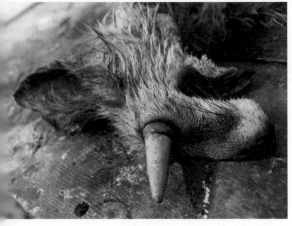

Figure 21

SPLIT AND TURN

You will want to cut into the fleshy lip skin between the chunky inner lip and the outer lip line, opening up and unrolling them so that the lip line feels relatively flat (Figure 19).

From the inside, the nose will look slightly like a tiny heart (Figure 20). We want to skin around it and split it down the center. A similar process applies to the eyelids, but there is not much skin to split. Cut into the inner eye skin until you see a thin black line appear (Figure 21).

For all mammals, it is ideal to split their ears open in order to make room for a stronger supportive insert. Between the skin and the earbutt there should be a noticeable line. You can gently push with the back of a rounded tool (such as a paintbrush), membrane separator, pinky finger, or carefully use your blade to locate this line before you split (Figure 22). We are going in between the inner skin and the outer ear with the cartilage attached to the backside. This is a very delicate process, so go slow. It is best not to move the tool but to slide the ear around over the brush (or finger) while it is in there (Figure 23). Once opened, you can use a pair of ear openers, but go slowly! You can get the paintbrush as close to the edges of the ear as possible without blowing out the ears.

Now the face is mostly prepped. If you

can easily spot out the whisker butts all around the snout of your specimen, carefully cross hatch between them without cutting through your skin, and thin it out with a skife knife (Figure 24). This can be done after tanning as well. Flesh the inside using borax and a scraping tool (Figure 25).

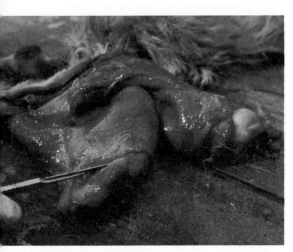

Figure 22

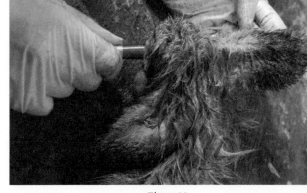

Figure 23

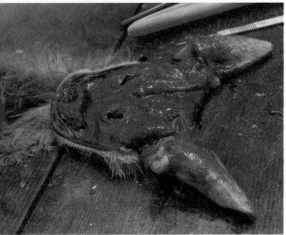

Figure 24

Figure 25

HOW TO CASE SKIN

Case or tube skinning is often done on small mammals or skins that are going to be used as garments, wallhangers, or display skins. The easiest way to do a case skin is to hang the animal up by its ankles. If this is for a garment skin that does not need to have feet, you can hang it up, running a string or wire between the back of the leg and tendon on the lower back legs.

If you are keeping the feet on, lie the animal on its back (Figure 1). Start your incision on the inner side of the foot (Figure 2). Part the skin down the leg and return back up to the foot. We are leaving the toes in this chipmunk, but we would skin them out of larger mammals, as we did with the fox and rat.

Skin down to where the toes start, then cut the toes off where they start (Figure 3). Then slit the leg skin down the

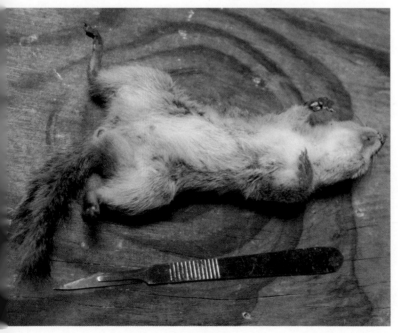

Figure 1

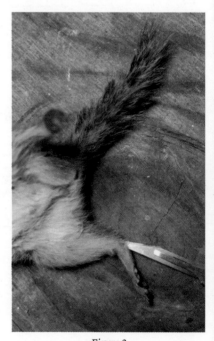

Figure 2

central backside all the way to the anus and genitals. Continue your incision between the anus and genitals, then reach across to the other side doing the same steps (Figure 4). For the tail, you can cut through the genital and anal tracts, then tube the tail like we did with the rat and fox (Figure 5).

Once the back end is done, you can begin pulling the skin down the belly, like a tube sock! Be sure to grasp the hindquarters firmly while doing so (Figure 6). This is why this process is also called tube skinning You can pull all the way until you get to the front

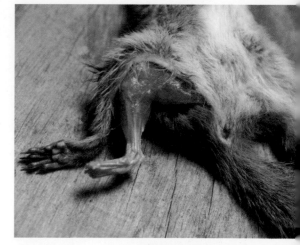

Figure 3

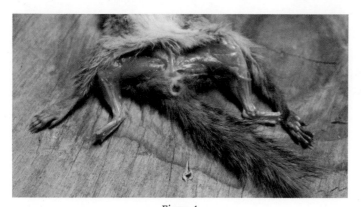

Figure 4

Figure 5

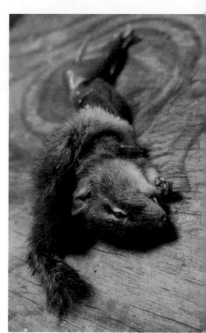

Figure 6

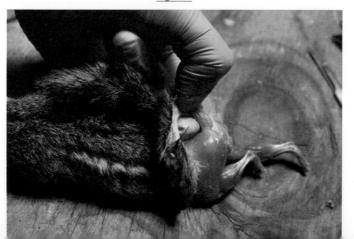

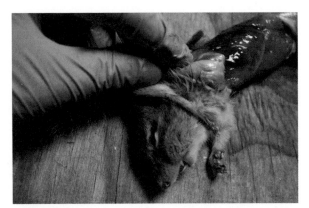

Figure 7

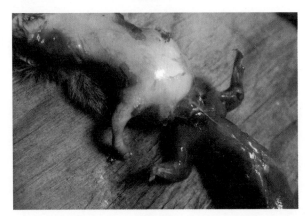

Figure 8

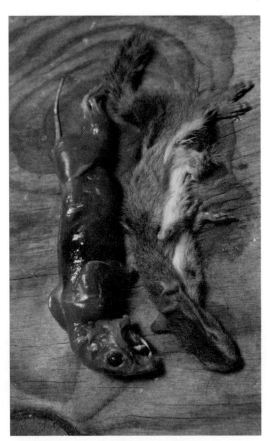

Figure 9

legs. You will have to peel the skin over the shoulders and cut a little down to the elbow. Pushing the arm into the body helps release it (Figure 7). Either with your blade or fingers, wiggle between the inner elbow and the skin. You should able to slip your finger in through a little window in between. Now you can use the gap for leverage and carefully work the skin down to the wrist. We are skinning down to where the toes begin and then cutting. For a wallhanger, you can cut around the ankle, leaving the feet on the carcass.

After the front legs are done you can pull the skin down again, stopping once you get to the back of the head (Figure 8).

Find the earbutts and cut as close to the skull as possible, exactly as you would with the rat or fox. Then do the eyes and the rest of the face. Now your skin is free, and you have to turn it inside out and flesh everything (Figure 9). If you want to mount your skin, you will have to prep the face by splitting and turning.

HOW TO VENTRAL SKIN

The word "ventral" refers to the underside of an animal, so ventral skinning means that this incision is made down the belly. This skin is quite delicate, and the internal organs are easy to access through the front, so this incision is better for a more advanced project or something that is going to be mounted lying down or used as a rug. We are doing a short ventral incision, meaning we are not slitting completely down each leg. Larger mammals, ranging from raccoons all the way up to something as large as a bear, usually have slits go all the way down each leg. Then the paws are skinned out like the fox's. But the method shown here works perfectly for small mammals like this guinea pig (Figure 1).

After measurements have been taken, lie the animal flat on its back, with the limbs as flat against its sides as you can get them. Begin to part the fur in a straight line down the center of the belly (slightly off to the side is also fine). Once parted, leave the specimen on its back with its face

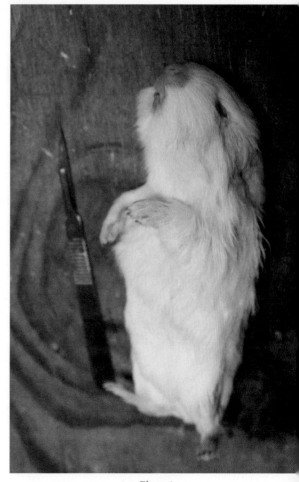

Figure 1

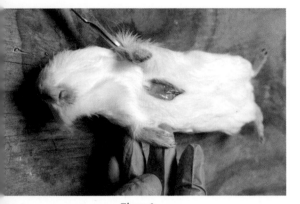

Figure 2

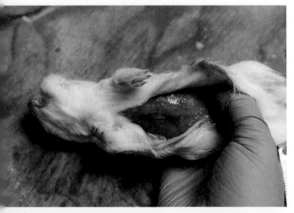

Figure 3

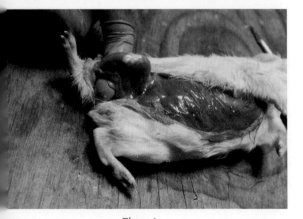

Figure 4

towards you. It is always best to cut with the direction of the fur when possible. Start your incision on the chest (Figure 2). You can puncture the skin, creating a hole, then slide the blade under the skin through the hole. The first puncture also allows you to see into the carcass and judge the actual depth of the skin. It's best to tread lightly here; if you go too deep into the carcass you will puncture internal organs such as the stomach or the lining that holds the intestines together, which is not fun! Use your fingers to cradle and release the skin like we did with the rat (Figure 3).

Push the limbs into the carcass just as we did with other skinning methods (Figure 4), then cut them off at the wrist and hock (Figure 5).

Once each of your feet and legs are free we can work around the back and genital area the same way we have done with the rat or fox. When all of that is freed up, we are at the head (Figure 6).

Lastly we need to release the earbutts, eyelids, lips, and nose, just as—we are sounding like a broken record—we have shown in previous tutorials. Now the skin is freed and you need to flesh, split/turn, and preserve your pelt (Figure 7)!

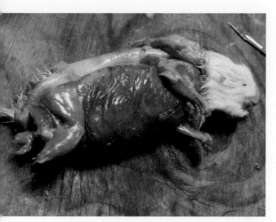

Figure 5

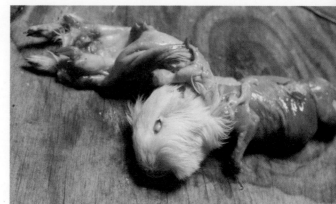

Figure 6

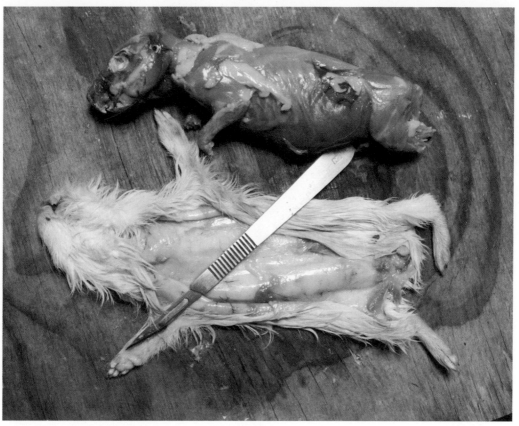

Figure 7

CHAPTER 6
BIRDS

YOUR SECOND PROJECT: A BIRD

Aside from Tippi Hedren, who doesn't love birds? At once primal and pretty, birds are a link to the dinosaurs and to magnificent creatures like the *Archaeopteryx* and *Ornithomimus*—and they fly!

We recommend birds as a second project because they pose some challenges that, in our opinion, are best addressed after getting comfortable with the more forgiving skin of a mammal and having a basic working knowledge of the foundations. However, if you are a bird fanatic, and you've been doing everything you can to keep yourself from flapping wildly, then by all means proceed with birds! Just make sure to go with a more hardy species like a starling, chicken, chukar partridge, or even a pheasant. Delicate birds, like some pigeons and doves (used in this tutorial because they're pretty) can be really difficult. They're fragile and they can be hard to handle.

This tutorial can be used for a number of less greasy birds, but if you're doing something like a big duck, goose, or anything very oily, you'll need more or specialized degreasing chemicals and a fleshing wheel.

As with mammals, freezing the specimen before use is advisable. Thawing in

denatured alcohol is optional, but it can help toughen the skin, making it a bit easier to handle—especially when working on extremely small or very thin-skinned birds.

Birds are usually skinned down the sternum, usually along the breastbone or keel. Although a bird's skin is covered in feathers, feathers do not grow all over the body. They grow in particular tracts and groupings that vary by species. The featherless areas of the skin are called apteria—one apterium is present along the breastbone, making it a convenient place to make our incision. A delicate hand and patience come in handy when working on birds!

PREPARATIONS

Bird anatomy can be a bit tricky, but careful and patient study will reveal all the mysteries held inside these mini dinosaurs. The feathers on birds can make them appear larger than they really are. Look at a poufy pigeon in the winter or a strutting turkey, and it all makes sense. But even on a deceased bird, one should take note of feathers and the volume they add (Figure 1).

For the purpose of this tutorial, we will be using and pre-serving the feet and skull with the beak, but you can also use reproduction heads and feet. It is also important to inspect your bird for any pinfeathers, as they usually fall out during the skinning and fleshing process. You can save these feathers and reattach them later, or you can designate the bird for a differ-ent end use altogether (if painstakingly reattaching feathers isn't your thing). As with mammals, you can pack the vent with some cotton, and it is also a good idea to pack cotton into the mouth and throat. Birds have these anatomical wonders called crops, which can be full of food in various states of decay. Spill-ing the contents can be worse, or weirder, than any type of poop you can imagine.

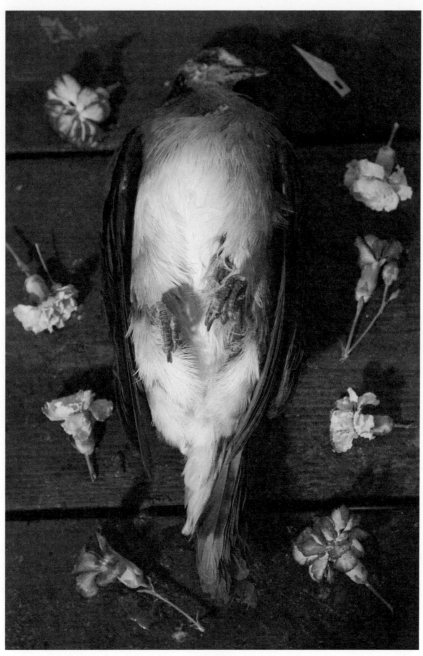

Figure 1

SKINNING

Think about the skin as a bodysuit you are unzipping and removing from the carcass. A bird's bodysuit is more delicate than a mammal's, and it will be unzipped from the front instead of the back. Washing the specimen in cool water helps clean and wet the feathers, and it exposes the sternum and bare batch of skin (apterium), along which you part the feathers and gently cut. Don't worry—the wet feathers will fluff back up at the end, and your bird won't look like a bad toupee.

The breast meat underneath the skin here is fairly thick (think chicken!), so you don't need to worry too much about puncturing organs in this area. Ideally, your incision starts at the very top of the breast (where it meets the neck) and stops just above the vent (Figure 2). Keeping this incision straight

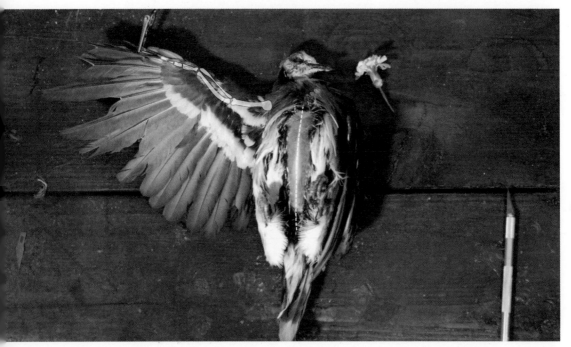

Figure 2

will help you realign your feather patterns later on, and the shorter your incision is, the less likely you will be to tear the skin at places of tension such as the tail and wings. In addition, you'll have less sewing to do later on.

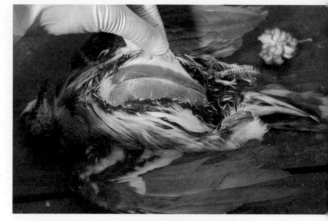

Figure 3

Using tweezers or your fingers, gently lift the skin and begin to peel it away from the breast and along the sides of the body (Figure 3). You'll notice fat, tissue, and all sorts of goo on the skin—we will address this later in fleshing. You can use borax (or salt and cornmeal if you plan on eating it later) and a massaging motion for a gentle abrasive effect and to help remove the skin in tough spots. Think undressing as opposed to pulling—like a sweet lover, you want to keep everything intact. Gently move the skin until you are able to expose the knee joint, and push it out towards the incision (Figure 4). Work the skin up and down the leg with your fingers to help expose the hip joint too (Figure 5).

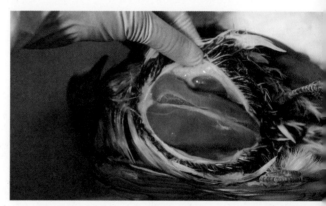

Figure 4

Snip the hip joints on both legs. (You'll have two legs—thigh and drumstick—attached to the skin. They'll be cleaned later.) You are cutting through and

Figure 5

Figure 6

Figure 7

Figure 8

around the joints here, not through the bone, so there shouldn't be any crunchy sounds (Figure 6).

Holding the bird upright, use your hands to skin around the vent and tail (Figure 7), the goal being to take the butt end out of the bodysuit, cutting straight toward the backbone if necessary. Work carefully, as the skin in this area can be a bit stubborn. For anatomical accuracy and cleanliness, you'll want to

keep the vent intact, carefully skinning around it. On a small bird, it can be easier to clean the meat off the tail feathers instead of skinning out a tiny tail (Figure 8).

Once the bottom end is released, work the skin up over to the wings Find where the wings attach to the body—look for the shoulder joint, working under and around the armpits

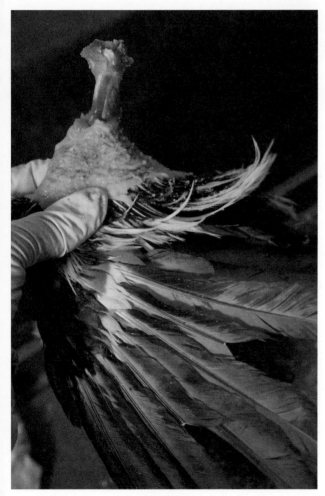

Figure 10

Figure 9

Figure 11

Figure 12

(Figure 9). Sever this joint on both sides, releasing the body (Figure 10).

The wing meat and bones are still in the skin—we will clean them later (Figure 11). Now work the skin over the neck and head. It helps to hold the carcass up and let the skin hang down, using your hands and gravity to roll the skin off like a sock or a stocking (Figure 12).

There can be tension where the head meets the neck. Some birds will need a relief cut here, but most can be worked with fingers and borax. For birds that need a relief cut, it helps to make it in a relatively hidden, easy to groom area, like the underside of the head. Be careful to keep the eyelids and ears (yes, ears!) intact (Figure 13). This can be done by scraping and cutting right up against the skull. It may leave a lot of goo on the skin, but it is much easier to flesh later than to repair a blown-out hole.

You want to skin just past the eyes, and don't feel self conscious about those large, creepy eyes staring at you (Figure 14). In this state, it is easy to see the connection between birds and dinosaurs. Now make a cut where the skull meets the base of the neck to finally release the body.

Hurray! You now have a skin (with skull, wing bones, and drumsticks in it) and a headless, limbless, carcass (that you'll use to help build your form) (Figure 15).

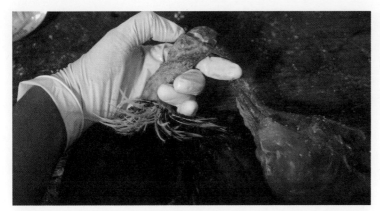

Figure 13

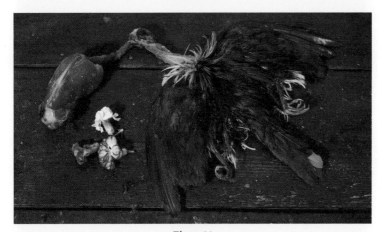

Figure 14

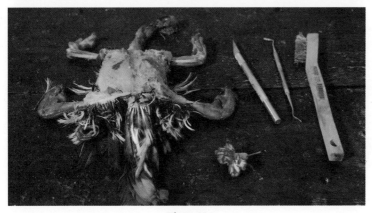

Figure 15

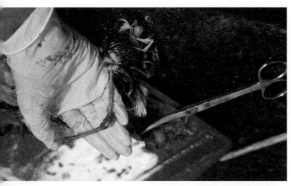

Figure 16

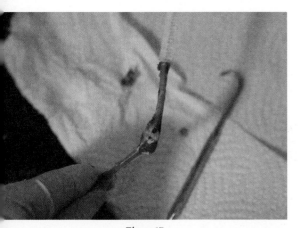

Figure 17

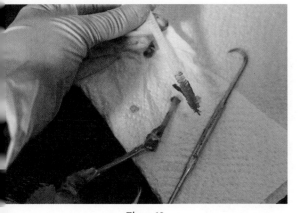

Figure 18

DETAIL CLEANING

Now we will clean up the nasty bits we left in the skin.

LEGS

After measuring and noting the size of the legs with meat, use a scalpel, or your fingers and borax, to clean the meat off these bones (femur and tibiotarsus) (Figure 16). The cleaner you get the bones, the better, as any leftover meat is food for bugs and bacteria. You will notice a small amount of connective tissue has been left in order to keep the bones together (but this is easy to fix in the assembly process if they come apart).

Once clean, it is time to remove the marrow from the bones (Figure 17). This can be done in a way that will remind you of that weird uncle who used to bite off the end joint of his drumsticks and suck it out. The difference is that you'll use a small saw or heavy-duty snippers and a pipe cleaner or awl. (You most definitely do not want to put a raw dead bird in your mouth.) You can also drill a hole on either end of the bone and use compressed air to force out the marrow as one long, wet noodle. (If you have an edible bird, cats love this as a treat.) However you remove the marrow, be sure to do it gently so the bone does not break

(Figure 18). If the bone does break, you can repair it with glue.

FEET

At the very bottom of the foot, in the meaty pad, make a small incision deep enough to expose a silky white surface. These are tendons and, with a bent wire or a small hook, use a picking motion to work around and remove them (Figure 19). Removing tendons helps decrease the amount of material that could rot. This makes wiring the feet easier because it opens up space for the wire and makes room for fillers if you are using them (Figure 20). After pulling the tendons, snip them.

TAIL

Work the skin past the vent around the tail (Figure 21). You'll notice a decent amount of meat stuck to the butts of the tail feathers, as well as two gleaming yellowish orbs. These are oil glands that must be removed. If you've ever watched a bird preen itself, it wasn't pecking at its butt—it was helping distribute oil from these glands to condition its feathers. It is best to remove the glands using borax and fingers or a dull scalpel blade. Be careful not to puncture them, as the oil can be surprisingly concentrated (smelly and slick). Use a wire brush or blade to remove

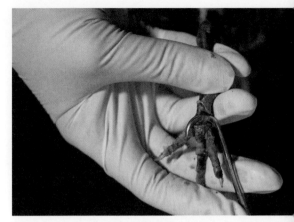

Figure 19

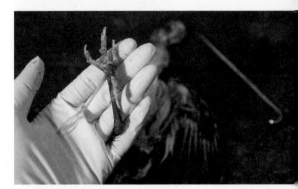

Figure 20

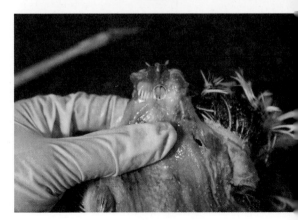

Figure 21

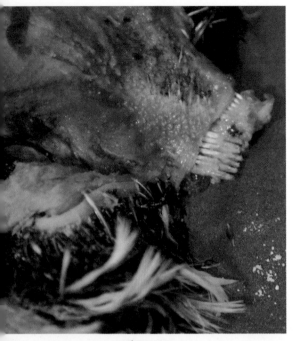

Figure 22

the meat from the butts of the feathers (Figure 22). You can see clean and dirty ones in this figure. Get 'em nice and clean!

WINGS

If you think of the wings like arms, we have the shoulder, elbow, and wrist joint, with the humerus, radius, ulna, and digits. We have a few options in cleaning the meat from the bones here. One is to skin the wings down to the wrist joint (Figure 23), working the skin like a sleeve, then cleaning the meat from the bones like we did for the legs (Figure 24). It takes a bit of finessing and some strategic cutting around the joints where the skin bends and tapers. The abrasive power of

Figure 23

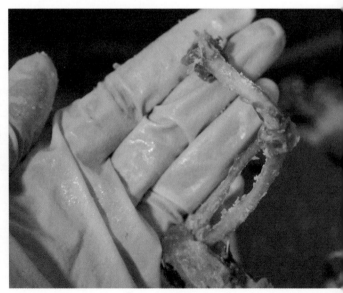

Figure 24

borax is helpful here. Another method is to make relief cuts from the outside, underneath the wings, following the radius and ulna, and clean the meat that way. (Some feel this is not ideal since it means more sewing and feather aligning.) A third way of cleaning the meat is to work down to the elbow joints, then use a modeling tool to work under the skin and into the "meat window" between the radius and ulna, cleaning the meat out using the tool, and pulling tendons as necessary to help. This is helpful on really small birds, but it can be hard to see what you're working on, so be careful.

Take your time and try to keep the wings intact. You'll notice that, like the legs, we left a little bit of connective tissue to keep the humerus, radius, and ulna together. But if they come apart, fear not; we can fix these while wiring!

When using these methods, you'll notice how the feathers lay into and align with the bones. You can even see/feel the indents in the bone where the feathers lay.

HEAD

Remove the eyes, and clean the meat off the skull using a scalpel, borax abrasion, a wire brush, metal picks, and/or witchcraft. Be sure to remove as much meat as possible, including the tongue. Make a hole in the back of the skull to clean the brains from inside the skull (these are now liquefied pink goo, and if you are brave, you can also use compressed air to make quick work of this) (Figure 25). Don't sweat it if

Figure 25

the skull is cracked or damaged during this process. It is fairly easy to rebuild.

When cleaning the bones, you'll notice that they aren't totally white (that color comes from peroxide whitening), but they're pretty damn close to it, with no traces of meat, fat, or anything remotely booger-like. They'll clean up more after they're washed too.

FLESHING

By now your bird is a flat shell of its former self, but keep in mind that if you had all your meat taken out, you wouldn't look so hot either. Examining the flesh side of the skin, we see that the feathers sit in a thin (or thick) layer of fat (Figure 26).

This fat (along with any meat or connective tissue) must be removed from the skin. You will also notice that in some areas,

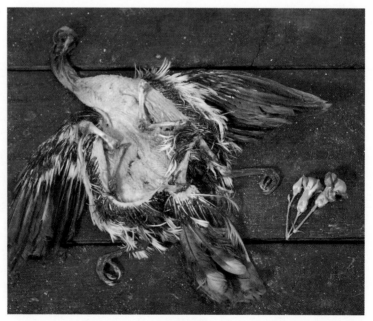

Figure 26

the feather tracts are very pronounced, while in others they are much smaller. Some areas may not have butts at all (remember the apteria?) and some areas of the skin may be nearly translucent.

We want to keep the skin and feathers intact while cleaning the skin, and the best way to do this is with controlled abrasion. Depending on how delicate the skin is, you can use a butter knife, dull spoon, borax and your fingers, or a wire brush (made of brass, nylon, or stainless steel), and use a fleshing beam or dowel for leverage. On hardier and fatter specimens, you can use a fleshing wheel.

Take your time, and be sure to work all around the feather butts until no more fat remains. Keep in mind that you will need to wash the skin and flesh it multiple times based on how greasy your bird is. Aside from eliminating stink and rotting, a clean skin makes for easier grooming. Your feathers will thank you for it.

WASHING

Washing birds is an almost holy ritual, and just like a trip to the banya, multiple passes must be made in order to ensure the complete and total removal of fat, grease, blood, and other stains. A degreasing soap such as Dawn or Totally Awesome is highly recommended, and for greasier birds, stronger specialized chemicals can be used.

After fleshing, a toothbrush can be used to work the soap and lukewarm water (too hot or too cold water can shock the skin) into a luxurious lather, paying special attention to the feather butts and dirty spots on the flesh side and feather side of the skin. Also be sure to get the bones, feet, and skull, washing each inside and out. A syringe or squirt bottle can help get the water into hard to reach areas.

Figure 27

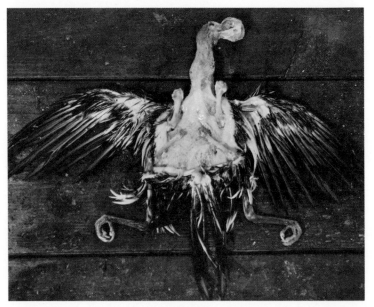

Figure 28

After the rinse water runs clear, fill a tub or bucket with a solution of lukewarm water and your choice of degreaser (the ideal ratio is usually a capful of soap for each gallon of water). Allowing the skin to sit in this for 15 to 20 minutes will allow for further degreasing action.

If any fat is left in the skin, you will notice it rises to the top (just as it does in broth) and/or that the feathers do not move freely. The feather movement difference is subtle, but it is worth training your eye to pick this up! On a clean skin, the feathers float and move freely, whereas dirty skin and feathers move only in unison.

Keep washing the skin, and re-fleshing if necessary, until no fat remains. Figure 27 shows clean (below) and dirty (above) feather butts. This can be a tedious process, but persistence will most definitely be reflected in your mount later on.

Once washed, soak the bird in a solution of fabric softener and lukewarm water (one capful per gallon). This softens and conditions the skin and feathers, and the fabric softener has somewhat of a degreasing effect. The skin can soak for 10–20 minutes. Remove and rinse until the water runs totally clear.

You can gently squeeze excess water from the skin, but do not wring the skin. Wet bird skin is very delicate and can tear (Figure 28).

If you have any holes in your skin, you can sew them up or use Super Glue to glue them shut if they are small—since bird skin is thin, it helps to use a dryer sheet as reinforcement in this process.

PRESERVATION

Bird skin can be preserved with a bird tan or dry preserve. Most birds are sufficiently thin-skinned for preserve to suffice, and world-class mounts have been done this way for generations. Apply your preservative to the skin, coating it thoroughly, and

shake off the excess. Thorough fleshing is key to the effectiveness of any preservative, and if using a tan, be sure to follow the manufacturer's instructions.

ASSEMBLY

For the purposes of this tutorial, we will assume that a body form has been built for the bird using wrapped body, as detailed in the form-building chapter.

Figure 29

Figure 30

You can now invert the head and tumble the skin dry using a dryer with NO heat, a bird tumbler, or a bag filled with corncob grit and sawdust, which helps absorb the remaining moisture. Some also use chinchilla dust and diatomaceous earth, as they can help absorb excess oils. The tumbling/powdering really helps fluff out and dry all the different feather layers. Birds can also stand up to a blow dryer on low, but make sure you dry the bird going in the direction of the feathers. Watch in awe as your feathers spring back to life. Be careful not to dry the bird so much that the skin gets crunchy. We just want the feathers to be dry and the skin to be flexible. On more delicate birds, you can apply the drying dust to the feathers only to protect the skin from becoming stiff and unworkable (Figure 29). Depending on the specimen and your

Figure 31

preference, you can build your skull and then dry the bird, or you can do so before doing any clay work.

SKULL

Using clay, resculpt the facial features, paying special attention to adding volume to the areas from which we previously removed it. Set the eyes into your clay being sure to keep them level and symmetrical by referring to the anatomy for shape and character of the eyelids (Figure 30). Some prefer to add the eyes after turning the bird right side out. Do what you prefer! Once the eyes are set, sprinkle some borax or dry preserve into the brain cavity before filling it with clay. Be careful not to use too much, as we don't want the head to be too heavy or large. Once your head is sculpted, carefully turn the head right side out (Figure 31).

BODY FORM

Chapter 7 goes into detail on making a wrapped body; ours is shown in Figure 32. Here we have made a wrapped body using a flexible, annealed wire for the neck (any wire you use for taxidermy should be rust proof!). The neck can be made from bird neck, foam, smooth layers of rope secured around the neck wire, or wrapped wood wool—just make sure it is smooth, curved into the natural S shape of bird necks, and that you have excess wire at the top to secure into the clay-packed skull. Some people find it easier to have excess wire stick out through the skin at the top of the skull or through the beak (in these cases, the excess is trimmed before the bird totally dries), but here we have simply trimmed it and secured it into the clay. Whichever method you choose, be patient when securing the body into the skull. Work slowly and be mindful of anatomy. Make sure to study your carcass and reference photos (including skeletal drawings) to be

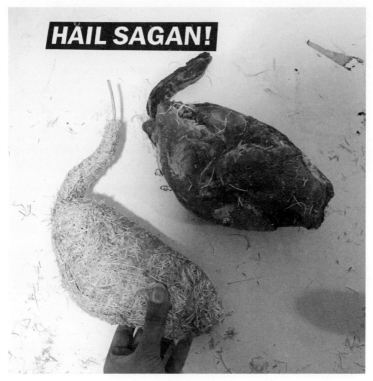

Figure 32

sure that the neck curve, leg joints/positions, and wing joints/ positions are all correct. Also note that it may be easier to wire your legs and wings before your body form in the skin.

LEGS

Cut a length of wire as long as the total sum of the leg from the tip of the bone to the bottom of the foot, with 4–6 inches of excess to use for attaching the leg to the form (at the top end) and the base (at the bottom end). The amount of excess will be based on the size of your bird, and especially with the legs, it is a good idea to have excess wire. Wire isn't made of gold, after all, and we can always cut away what we don't need.

Using a strong wire is key, as this will be what your bird

stands on. Use the thickest gauge possible that will not damage the feet. (A good guide to use is the empty space left by the removal of the tendons in the legs. Use a wire that will fit well in this space.) To wire your legs, run the wire alongside the bone (where our meat used to be), then work and wiggle it around the ankle joint so it can be threaded into the foot where the tendons used to be, with some of the excess running out the bottom of the foot. This can be done from the foot going upwards or from the skin going downwards. Having a sharp end to your wire will help.

It will take a bit of practice and patience, so do not be discouraged if you don't master it on the first try. It isn't every day that you are trying to make a dead bird stand again (at least not yet!) (Figure 33). Once wired, use electrical tape or wrap thread to secure the wire to the leg bone, minding the excess wire on either end (Figure 34). Don't forget, you want enough to attach the leg to your form and base! You may also use thread or wood wool to rebuild the musculature and volume of the legs around the bone (Figure 35).

WINGS

Wiring the wings is done similarly to the legs; however, you can use a wire of a lighter weight. Cut a length of wire as long as your wing (from shoulder to wingtip) with 4–6 inches of excess. Run the wire along the wing bones, noting that the excess on one end of the wire will protrude from the very tip of the wing, while that on the other end will be attached to the body form. A more advanced technique is to work the wire past the wrist joints and sink it into the space between the digits (Figure 36).

You can use electrical tape or thread to secure the wire to the wing bones and keep them running smoothly together. To

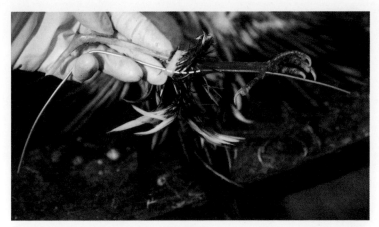

Figure 33

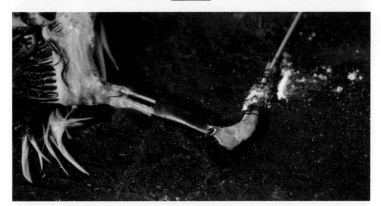

Figure 34

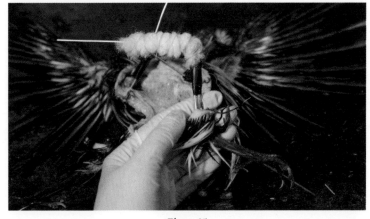

Figure 35

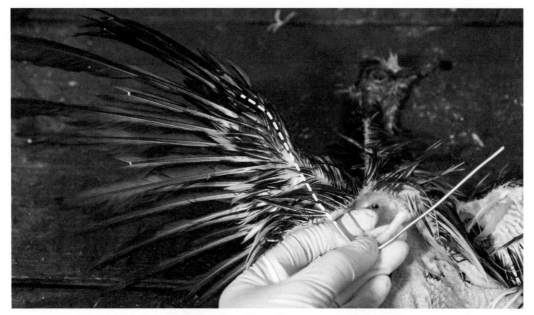

Figure 36

fill out and rebuild the wing meat, you can use polyfill, cotton batting, or caulk (this takes getting used to but works wonders once you get the hang of it!). Glass cleaner helps remove caulk from feathers in case you get any on the feathers.

TAIL

Now that the meat has been removed from the tail, you will notice a U-shaped cavity. This will be supported by a wire bent into a U-shape that is glued to the feather butts, then hooked into your body form using hot glue. This is done from the outside in, and the wire will be hidden between the layers of tail feathers. You can use caulk or polyfill to fill small excess spaces here too (Figure 37).

Once all parts are built, hook the wing, leg, and tail wires into the body form. Match the attachment points to the ones on the carcass. Be sure your wires are hooked into the body form

accurately and securely, and trim any excess interior wire if needed. It is also a good idea to pre-bend the wings and legs so you don't ruffle the feathers too much after sewing (Figure 38).

SEWING

Bird skin is delicate, and sewing it up takes patience. Using a thin needle and monofilament thread, make small stitches as close to the incision as possible. To make the stitch invisible, be sure to pass the needle from the flesh side to the feather side with each stitch (Figure 39).

As you sew, be sure to unroll any of the skin that may be curling up onto itself, and keep the feather patterns aligned (Figure 40).

If you are using caulk to help your skin adhere to the body form or to help fill out any empty parts, it is a good idea to add it using a syringe or caulk gun strategically aimed underneath the skin while sewing, being sure to keep it away from the incision and the feathers. You can always massage and redistribute the caulk after sewing and while posing. Some

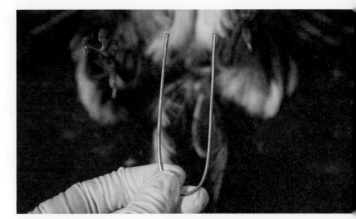

Figure 37

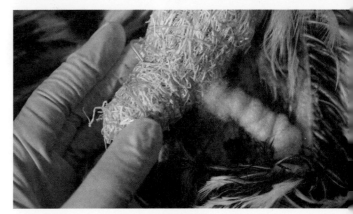

Figure 38

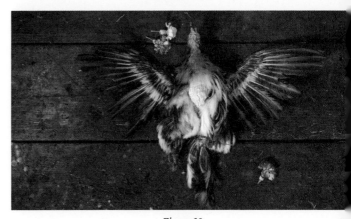

Figure 39

Figure 40

also choose to add caulk after the bird is sewn up, making strategic incisions and injecting, then pinning the skin shut.

Once the incision is closed, tie off a needle knot and take a deep breath. Congrats!

FINISHING

Position your bird as desired, being sure to move the skin to match the anatomy. Keep in mind any folds, creases, and pockets, especially in areas such as the thigh, hip, and under the wings. Remember that "taxidermy" root words come from "arranging skin" and that birds are no different. Arrange that skin! Any unruly feathers can be tamed with more powdering, blow-drying, or even a gentle steaming and brushing with a soft makeup brush (Figure 41).

The excess wire sticking out of the wings and legs will help you position those parts. It helps to put the leg wires into a foam base (just for drying), as this gives you nearly endless

pose options. Keep in mind, the bends in bird joints are not the same as the bends in mammal joints—study your reference photos closely. A common mistake is to miss that S-shape bend in a bird's neck—this helps the feathers lay properly and plays a huge role in your bird looking peaceful and natural. Another common mistake is to bend the leg joints backwards, but keeping the bones in serves as a guide to where things should be placed (Figure 42).

If you used caulk, now is the time for a caulk massage, being sure to smooth everything out. When the feet are posed, inject them with a filler to keep them from shrinking. (Master's Blend is a well-known filler, but as it dries quickly it can be challenging to work with.) On the face, tuck and position the eyelids and cheeks, working while the clay is wet so the skin adheres to it. You may need to use pins or some props to help secure the bird as it dries and as you groom it.

Detail grooming and feather tiling birds are processes that can take hours or even days, but it is worth every moment to have a beautiful, accurate mount (Figure 43). Reference photos come in handy here, as they will guide you on feather placement and patterns as well as the overall look of the bird in your desired pose. Feathers are designed to interact with the air when a bird is alive, and air is a great tool to groom them. A blow dryer

Figure 41

Figure 42

137

Figure 43

on low or compressed air can work wonders in fluffing them
out. Tweezers help align and define patterns, and painter's tape,
fishnet, or twine helps train the feathers and keep everything
in place as it dries. Cards made of wire mesh or stiff cardboard
(Figure 44) keep the wings and wing feathers properly posi-
tioned as they dry (Figure 45). Add padding to avoid creases.

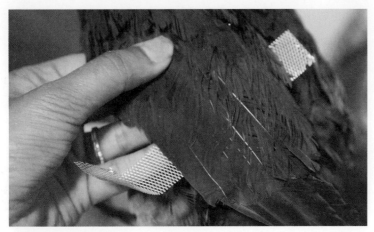

Figure 44

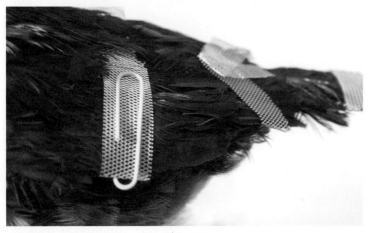

Figure 45

Once your bird is dry, you'll notice the colors of the beak, feet, and other bare skin are faded from the drying skin and the preservative taking action. You can now use paint to match the original colors of these parts to your reference photos. On birds with eye rings, these will need to be sculpted, painted, and applied around the eye. Once all the painting is done, be sure to use a sealer to protect the painting and work. Congrats on mounting your bird!

CHAPTER 7
FORMS AND FINISHING

You've skinned, fleshed, and cleaned a critter, and you are eyeing up your reference material. Now what? It is time to make a form!

There are three major techniques for creating a form, each with its own advantages depending on your particular situation: wrapping, carving, and casting. The most important part of making a form is creating an exact and ideal replica of the carcass, capturing what the animal looked like when it was alive. Keep in mind all the folds and wrinkles in the skin. This is one of the main things beginners don't compensate for. Most beginners make their forms too big and it doesn't fit, or it just looks like a sausage about to pop. It takes a ton of practice and anatomical study, but the more you do, the better you'll get.

WRAPPED BODY

Wrapping is one of the oldest form-making techniques that is still in use today. Wood wool, also known as Excelsior, is perfect because it is lightweight and extremely versatile. With just a few materials, you are ready to create a custom-made form for nearly anything that may come your way. It's also cheap!

To create a wrapped body, you compress and wrap wood wool around a wire armature (Figure 1) (think of the wire as replacing the bones, with wood wool replacing the meat and muscle). To recreate the anatomy accurately and allow the

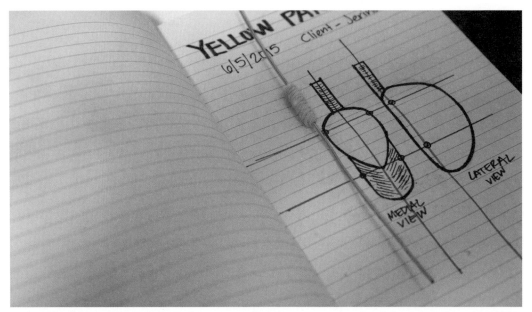

Figure 1

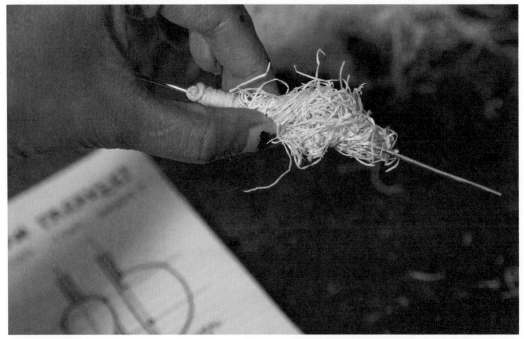

Figure 2

skin to be taxied into the bends, folds, and creases, wood wool forms are generally built in separate pieces—torso, two back legs, two front legs, and tail for mammals, and torso with neck on birds (as shown in our birds chapter). The only thing you can't make with wood wool is a head. So, mammal heads should be carved from foam and bird heads can be done with clean skulls or replica heads. Some people work off of measurements taken from the carcass, while others prefer to make tracings of the carcass with measurements, marking the positions of the joints and limb attachment points. Whichever method you use, be sure to check your wrapped pieces against your measurements and carcass for accuracy.

It is important to wrap your wood wool tightly for the best results. You are taking a soft material and compressing it to the point that it becomes rock-solid—this way, your skin has something substantial to dry up against, which will result in a stronger and more durable finished piece. This also ensures that your mount doesn't have that "stuffed" look! Building a form with wood wool is best done by adding, wrapping, and compressing bit by bit, focusing on each specific part of the anatomy. Don't try to grab a glob of wood wool (Figure 2), then expect it to perfectly replicate the anatomy in one round. It just doesn't work that way! By adding little by little, you'll get a much more detailed and refined shape. You'll also get used to wrapping and seeing how much compression is possible versus how the wood wool looks when it is loose. To wrap, we use a poly or nylon thread (Figure 3), although some prefer using waxed thread or rope, as they find the skin slides on easier. You want to make sure your finished shape is a smooth replica of the anatomy of the specimen you have. Any unevenness or lumpiness will show through (Figure 4).

For super-small animals, like mice, you may not be able to

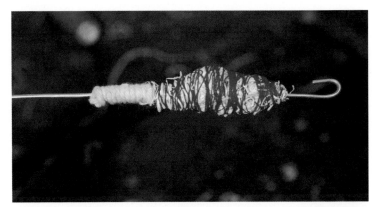

Figure 3

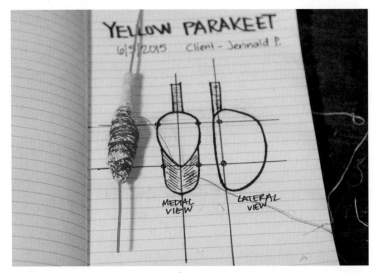

Figure 4

get the wood wool to compress into a small enough shape for the legs. Here, you can wrap with cotton, polyfill, raw wool, or jewelers tow. These materials are finer and will allow you build volume slowly, but remember to wrap them so they're super hard (Figure 5). Some find wetting the wood wool helps compress it too.

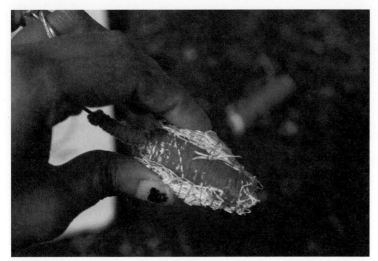

Figure 5

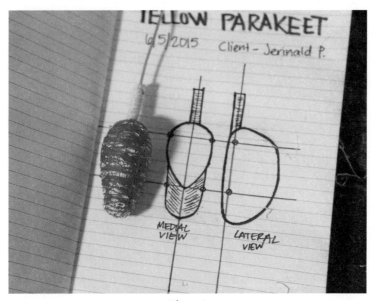

Figure 6

When attaching limbs to your wood wool, be sure to securely hook them into place so they do not wobble. If a hook does come loose, it may mean that you need to tighten it some more, or you can use the excess wire that sticks out through the skin side to pull it back into place. Create a C-shape hook at the back end of your body, then pull the wire coming out from your wrapped neck. We want the hook to be pulled into and secured inside the body. Use your outline to see where the limb joints and tail attach (Figure 6). Here we made a bird body, but for a mammal, the procedure is similar. Wrap your torso and limbs around appropriately sized wire and connect it all with the same C-shaped hooks. Once your body is made, double check it against your carcass or drawing.

CARVING

You can also create a form by carving it out of high-density foam. For the love of all that's good, please don't use that white styrofoam they sell for crafting. For lasting results, you've gotta use carving foam! Some art supply shops sell this, but it can also be found at taxidermy supply places.

It is helpful to create the form in pieces (torso, front legs, back legs), but keep in mind that unlike with a wrapped body, there is no flexibility before the skin slides on. So if you want a bent leg, the foam must be carved with the legs bent into that shape. Foam is also lightweight, and its hardness means it can get smoother than wood wool and take some more detail—which is important for thin-skinned animals or animals with shorter or lighter hair, such as fawns and piglets.

When wiring your foam, you may need to drill or gently poke out holes using an awl or drill in order to keep the foam intact, and to save your hands from being stabbed. Like Michelangelo approaching a block of marble, get on that foam.

Carving

It is helpful to trace the carcass directly onto the foam, starting with matching the shape from one dimension, then moving into the others.

Be safe when working with foam. Use a sharp knife and focus on taking away small pieces, bit by bit (remember: Michelangelo!). You can use a carving knife, a utility knife, or a hot knife to cut foam, and you can use sandpaper or sanding blocks to smooth it out.

When carving heads, be sure to mark eye and ear placement, carving out details accordingly, and be sure to carve a channel into which your lips will be tucked. To assemble your foam pieces, you can use wires with hooks, as we did with the wood wool body. Or, for larger animals, you can use drywall screws and body-filling putty. Remember to carve out and account for creases in the body such as the crotch, thigh creases, and armpits. The body naturally has these areas, and the skin moves with it and should be tucked in accordingly. Be sure to protect your eyes and respiratory system from dust while working with the foam; there's usually tons of sanding involved.

CASTING AND MOLD-MAKING

Casting and mold-making may sound scary, but it just takes some time and planning. This process involves making a mold directly from the carcass, then casting a two-part foam into it in order to create your taxidermy form. By creating a direct replica of your individual animal's anatomy, you are ensuring the utmost accuracy. And it is just really freakin' cool. The disadvantage is that this process is time-consuming and can get expensive, but the results are satisfying. There are a number of ways to do this—plus an endless number of books and videos dedicated to the topic—but here we will show you the simplest

Forms

ways that we like. Once you are comfortable with these techniques, you can expand from there.

Please be sure to read the MSDS and manufacturer's directions for the materials you are using, and take the right measures! Huffing isn't fun. It is a good idea to read through the directions from start to finish and verify that you have all the materials on hand before proceeding to make your mold.

SILICONE MOLD OF A HEAD IN A CUP

This mold-making technique uses a container to make a one-piece mold of a small part, like a head. We use silicone here since we want to make a mold that can be used numerous times, but you can also use this technique with alginate to create a single-use mold to cast something like a death mask.

Interior of bear death mask mold

WORKING WITH A HEAD THAT IS FROZEN SOLID
OR COMPLETELY DRIED OUT

You can remove the eyes or drill them out of the finished foam head. Silicone sticks mainly to itself, but using a mold release is a good idea to make sure things go smoothly. If you are going to be casting anything with fur or feathers on it, like for a death mask, be sure to use a mold release, as silicone will stick to everything!

Select a container that is appropriately sized for the head you will be making the mold from. The container should be non-reactive with the silicone, and it should also be rigid enough to stand up to the silicone. Plastic food containers, inexpensive cups, and old boxes are all good options.

Suspend the head in the container without touching the sides or bottom so that the silicone can be poured all around it. We like to work with the point of suspension being the same as the point of pouring. For heads, the easiest part to do this is at the foramen magnum, or the base of the skull where it meets the spinal cord. Insert a dowel into the foramen magnum, and use a wire or line to keep it secured and suspended in the container.

Now pour in your mixed silicone. Follow the manufacturer's directions on how to mix. Pour slowly to minimize air bubbles. You can also shake and tap the container to make sure the silicone it fully settled and covering every part of the head. Be sure to have silicone cover the entire head and part of the dowel (this will create a place for you to pour the foam and allow for the insertion of a wire too).

After the silicone is fully cured, remove the head. The removal of an object from its mold is called "demolding." You now have a block of silicone imprinted with the shape of your head—a.k.a. your mold! The cool thing about silicone is that it stretches and is really resilient. You can make one carefully

placed cut so that the extraction of the head is easier, but you may not need it.

Rinse out the inside of the mold, especially if you used a frozen head; you may notice it has thawed out a bit and left some fluid. It should wash out with water. Make sure the mold is totally dry before casting into it!

To cast into your mold, place your silicone mold back into the container you originally poured it in. The hard container will keep all parts of your silicone mold in place, which is especially important if using an expanding foam that will have the tendency to move wherever it wants. You can use a funnel to make pouring easier. To keep things clean, you can line the funnel with paper or masking tape. This makes easy cleanup for hard to clean or extra-sticky materials, as you can easily discard the paper.

For casting a head that will be used for a manikin/taxidermy form, use a two-part urethane foam. This is a urethane foam that expands to ten times its original size. To calculate the amount of material you need, first determine the volume of liquid needed to fill your mold by filling it with water and then pouring it into a measuring cup. Divide this amount by how much your foam expands (6x, 10x, etc.) to figure out how much foam you need. Of course you can guesstimate, but err on the side of caution since you do not want to waste too much foam. If you mix up too much, you can always use the excess foam for carving, whether for habitats or small parts. If you need more foam in your mold, you can wait until it is cured, then mix and add more.

Measure out and mix your foam as per the manufacturer's directions and pour. Be sure to mix thoroughly so the resulting foam is strong and cures properly. For a head that will be used on a body, you can add a neck and support wire into to mold so the foam dries around it, preventing the need to drill wire into the foam.

Carefully pour the foam, being sure it reaches all parts of

your mold. You can rotate the container to ensure this. After rotating, let the foam expand and set. When fully hardened, carefully demold your new piece.

Boom! Now you have a molded head! From here, you may need to smooth and sand your piece—and of course you'll need to do your clay work before mounting—but you've entered the wonderful world of mold making. Congrats!

TWO-PART MOLD OF A BODY USING BUILDING BLOCKS

For this tutorial, we use a box built from a certain Danish building block as the container for our plaster mold. This provides both a number of options for customization. But you can use any box that works, as the principles are all the same. Any box with 1 inch of space above casting will work. On larger animals, where the extremely large amounts of clay may be limited, you can also use firmly packed sand instead of the clay.

Building block mold

On the piece you are molding, draw a line that bisects it using a marker. Again, we want to make sure our piece is frozen solid or dried out. If the piece is dried out, we will need to build out and fill in the volume lost due to death and desiccation. If you are going to use a frozen carcass but have noticed shrinkage, you can also inject it with water after it has thawed, then carefully re-freeze it so as to achieve lifelike volume and muscle tone in your mold. When freezing your carcass into the position you would like, it helps to check on it and reposition it every few hours to make sure it is freezing into the exact shape and position you want.

Using oil-based clay, build a dam around the carcass, up to your halfway line. Be sure your dam is tight. This is important in controlling where your mold-making material flows and what shape your piece comes out in.

Add keys to the clay. Keys in a mold are guides that will fit together like two pieces of a puzzle, ensure your finished mold will align, and accept your casting material. You can use marbles—their impression in the casting material will create the "negative" side of the puzzle piece. You can also use a straw or dowel to create your pouring hole or lay wires or rods in at this time to create channels in your finished foam casting. Notice how everything is sunken into the clay up to the halfway line.

Coat your keys, dowel, and carcass with a mold release like petroleum jelly. Mix your plaster according to the manufacturer's directions. Salt can be used to help accelerate the drying, which can be helpful for more advanced mold makers who work quickly. Pour your plaster into the container over the carcass, keys, and dowel. If you are molding something large and desire a stronger mold, you can pour a layer of plaster, add strips of cheesecloth or burlap while the plaster is wet, and follow up with another layer of plaster. The fibers will help strengthen

your mold. Be sure to mix enough plaster so you can pour it at least an inch above the highest part of your specimen. Then tap the liquid surface and box. This helps remove air bubbles and force the plaster into more detailed areas.

Once the plaster is completely dry, remove everything carefully from the container. We will need to mold the other side, so make sure your guidelines are still intact. You can remove the keys when pouring the second layer, since this layer will have the "positive" side of the puzzle. If your carcass is too thawed out or losing integrity, carefully re-freeze it in the same position, even if just for a few hours. The plaster creates heat while it dries, so don't freak out if things are a little warm or fragrant.

To mold the other side, place everything back into the container with the unmolded side facing up. This includes the keys, dowel, and our lovely carcass. Cover it all with the mold release. Mix and pour the plaster as you did with the previous side.

Once everything has set, it is time to demold. You can wipe up any blood or other fluids too. Before casting into your plaster mold, let it dry out for 36 to 48 hours. This will ensure all the plaster is totally dry, especially the parts that were sitting up against the carcass. Letting it dry for a few days ensures there is absolutely no residual moisture. After it is dry, you can sand and smooth the mold, using your carcass for reference, focusing on any lumpy or uneven parts. You can then use a spray sealant to seal the plaster, which will make your mold more durable and less porous. This will also make your castings easier overall.

Apply mold release into the mold, and lay wires or rods as applicable into your channels. Use belts, clamps, or ties to hold your mold together, making sure the keys align and the mold is sealed tightly. Then measure, mix, and pour your foam as previously instructed. Demold after the foam is cured. In some cases, plaster molds are seen as single-use molds—plaster is inexpensive, and

foam sticks to everything. If this is the case with your mold, you can break the mold in order to remove the finished foam piece.

BONDO MOLD

Bondo is an auto-body filler that is used in taxidermy as a filler, mold making material, casting material, and general repair agent. Here we use Bondo to make a strong, lightweight mold without the need for a box. For poses and species with undercuts, especially for legs and limbs, you can cut them off and mold each piece separately, or make a multiple piece mold. This is especially helpful for larger specimens.

First, freeze or dry out your carcass as previously described,

Bondo mold

adding volume as needed. Using a marker, draw a line that bisects you piece. With a Dremel rotary tool or other tool of your choice, carefully carve out a shallow channel in this line.

Using playing cards or other inexpensive pieces of cardstock, build a fence along the channel you carved. By overlapping the cards, you ensure a smooth connection and strong fence. You can also use tape to hold the cards together. You want to make sure your cards are firmly wedged into the channel. For specimens where you have multiple undercuts due to the pose, you can cut off the limbs and mold them separately, or you can make a mold with multiple parts by making multiple lines and multiple card fences.

Now, apply mold release to your carcass. Mix Bondo or similar body-filling putty according to manufacturer's directions and smooth it onto your carcass, being sure it sticks to the carcass and captures your details. Work it all the way up to your fence of cards.

As the putty sets, work on covering the other parts of the carcass with putty. If your specimen starts to thaw, you can re-freeze it to keep it in shape. If you would like to strengthen your putty, you can use chopped fiberglass between layers, but follow MSDS precautions!

Once all the putty has set, you can demold your original. Wipe up any fluids or blood that may be in the mold. After all excess moisture has dried, identify where you would like your pour hole to be and drill it. You can also carve out channels for rods and wires that will be in your finished foam.

Coat the inside of your mold with mold release. Use clamps, belts, and ties to hold all pieces of your mold together. Then measure, mix, and pour your foam as previously instructed. Once the foam has set, demold.

After demolding your foam castings, you may notice that your form is not as smooth as a commercial form, or that there

are seams where the mold has come together, or some uneven-
ness around the pour hole. This is normal! Use sandpaper,
sanding blocks, and your rotary tool to smooth these areas out.
And get ready for a dust fest. If you desire more muscle details,
especially for thinner-skinned animals, you can carve that into
the foam. There is only so much detail the foam will pick up in
the mold. You will also carve out areas to tuck in thigh, crotch,
and armpit skin, and for tucking eyelids, lips, and earbutts.

COMMERCIAL FORMS

If you are mounting an example of a popular species, such as a
white-tailed deer or squirrel, you will find a dizzying variety

Commercial forms

of commercial forms. When you are selecting a commercial form, measure your specimen and then check the measurements of available forms provided by the supplier. Usually these measurements include nose to base of the tail, belly girth, neck girth, and nose to corner of the eye. Like people, animals—even of the same species—are all a little different. Four people can wear a size ten dress but have completely different body types. Even with a variety of forms are available, you may still need to make some adjustments. Order a form that is closest to the measurements of your specimen, knowing that you may need to alter the form when it arrives. And if the readily available form is a perfect fit, you will still need to do some prep work in order to make it ready for your skin.

BASIC FORM PREP

Much like our carcass casts, commercial forms are cast into hard molds and may have mold release on the outside, along with seams, item numbers, and other things that need to be smoothed out. It is important to sand off the shiny finish of the mold release in order for the hide paste to stick (where your stout rougher comes in handy!) and you will smooth out the seams and carve out creases for tucking the skin.

PAWS AND FEET

On some animals, the paws and feet are molded into the form. On others, they are not. If you have skinned down to the last toenail (which we prefer on anything larger than a rat) you may find it difficult to fit the premolded feet into the foot. You can use a rasp to remove some of this volume so that the foot fits. Don't forget that you will need to put some clay into the feet so it fills out the toes too. Nobody wants saggy toes!

FACE

You may find that you need to hollow out the eyes so they sit properly in your form, carve out a channel into which the lip skin will be tucked, and carve out holes in which the earliners can sit. Many forms suggest the corresponding eye and earliner size. Take a note of this and measure it against your specimen. You may need to adjust slightly. Earliners can easily be trimmed or sanded, and the eye area on the form can be made larger (by carving it out) or smaller (by building it up with clay). Studying your reference, you will use clay to sculpt the eyelids, earbutts, and other facial details. The clay is what the facial skin will stick to. Be sure to leave a channel for your eyelid and lip skin to be tucked into!

TAIL

Depending on how epic the tail is, you'll need to use a wire and some fillers to sculpt the tail, as it will probably not be included in your readymade form. Premade tails are sold for some species, but they may need alterations, and it is easy enough to make your own by wrapping, molding, or carving around a wire.

FITTING

Putting a skin onto a form is like getting dressed, except you're putting tight clothes onto a rigid body. A stretchy tan will only do so much. Depending on the incision used, you may find that you need to cut the form in half to make it fit. Use a saw to cut the form at an angle to ensure it fits back together and can lock into place. You can use screws and body-filling putty such as Bondo to reinforce the reattachment.

FORM TOO SMALL

You can add to a form by using putty for small amounts of volume, or urethane foam poured into a guided area. You can use cards, masking tape, or scrap paper to build an area for pouring based on what needs to be added. Look at your carcass and base your additions on the measurements taken from your carcass.

FORM TOO LARGE

Before you go on an uninhibited sanding spree, look at your carcass and take measurements. Remove evenly and gradually from the areas that are too big, being sure to keep the shapes anatomically accurate. Use a rasp, sandpaper, or rotary tool to do this.

USING HIDE PASTE AND CAULK

This can be intimidating, as you don't want to get glue all over your beautiful skin (even though it can be removed with solvents). The easiest way to use hide paste is to apply it after you have test-fitted your skin onto the form (that way you know your form fits and that the skin is stretched and ready). With a gloved hand, slather the paste onto the form, and slide the skin onto the form. Another way to apply hide paste, especially if you have multiple seams, is to fit the skin onto the form and then use a caulking gun, syringe, or your hands to apply it between the skin and the form, massaging it into place. This way is less intimidating but can present some problems if you don't get into every last nook and cranny. Caulk is mainly used on birds and can be applied just before or after sewing it up.

PINNING AND CARDING

You are the boss of the skin, and you will tell it where to go and what to do! Skin, even after tanning, is organic matter

Pinning and carding

that will dry however it pleases unless you put it in its place, securely. Carding, pinning, and tucking are important parts of taxidermy, as these are what ensure the skin dries how you want it to, and not how it organically chooses to. Depending on how thick the ears are, there are a few ways to card ears, including using cardboard or cardstock, masking tape, or wire mesh. Carding ears keeps the skin in place and makes sure the ear skin presses up snugly to the earliner so that the adhesive can work effectively. You may also find the need to card creased areas or muscle detail so the skin sticks to the form, is in perfect alignment, and doesn't move. This can be done with

cards and pins (or staples or brads for things with thicker skin). When tucking areas like the lips and eyelids, work carefully so the skin is smooth and so you don't disrupt your clay work. Use the thinnest pins possible without compromising strength, and be sure the pins go through the inner part of the skin that is being tucked, so there are no visible holes. Make sure the paws and toes are all in place and drying in the shape you want (curved, flat, or any other configuration that can dry directly on your habitat, or on a piece of foam or wood shaped like the final habitat). You can use pins to guide them into place too, but don't pin directly into the feet as you may have visible holes! For birds, wings can be carded similarly to ears, with cardstock and masking tape or well-placed wire mesh. After grooming a bird, you can use masking tape, string, or even sexy fishnets to hold the feathers in place as the skin dries. Keep in mind, the skins needs to breathe in order to dry properly. You should check on your mount daily as it dries. If you want to speed up drying, you can use a gentle fan. If you want to slow down the drying time, you can put a bag over your mount, but be mindful of too much humidity in order to discourage the growth of anything that could cause slippage. Only remove pins and cards when your mount is completely dry!

GROOMING

Everyone loves to be pampered, and your taxidermy is no different! Birds need to be groomed before the skin dries up, sometimes with daily adjustments to make sure everything dries in place, whereas mammals can be groomed before drying—especially to set the hair patterns—and after drying, to fluff up fur and hair. For birds, use tweezers to groom and taxi all the feathers into place. Before you sew up the bird, make sure the feathers are as

Painting

dry as possible with the skin still flexible. Tumble in chinchilla dust, corncob grit, or potato starch. Use compressed air or a blow dryer to fluff out feathers or get them back into the right shape. Blow-drying also works great for mammals, along with lots of brushing. Fur brushes from a pet shop, wire brushes, hairbrushes, and toothbrushes are all good grooming tools. A clean makeup or mascara brush can also help with grooming feathers. Dry shampoo and hairspray can be used too. This is done in the same way that you'd use it on your head—unless you're one of those people who overdoes the hairspray!

FINISHING WORK

Carefully remove all pins from your mount; a pair of needle-nose pliers is very helpful here! Use a toothpick or modeling

tool to scrape off any excess clay around the eyes, lips, and bits inside of the nose. For thin bits of clay stuck on the outside of the nose, and/or glue around lip line, use a wire hardware brush. (Note: Sometimes the eyelid skin can become light-colored, a result of epidermal slippage. It can look similar to the clay but it will not scrape off.) Clean your glass or acrylic eyes with an appropriate cleaner before this next process. To fill in holes left from pins, the interior of nose, and gaps in the lip line, evening out of fixing/detailing nose, use Apoxie Sculpt or any other two-part, 1:1 mixable epoxy clay.

PAINTING

For painting, experiment with small amounts or samples from different brands, and invest in a set of the one you like best. If you've never painted anything before, practice on paper, wood, or similar surfaces to the ones you will be painting in order to practice. Despite everything you hear about lacquer-based vs. water-based paints, at the end of the day, the best formula is one you are comfortable with that gives you the best results. Both kinds of paint have produced excellent mounts and terrible ones. Black, gray, dark brown, medium brown, light brown, red, flesh pink, off-white, and yellow make for a good palette for beginners that can be used across many different species. You can add to your palette as your particular specimen requires.

When working with an airbrush, be sure to clean your airbrush after each use. The more thoroughly you clean it, the better it will perform and the longer it will last through the years. Some paints need to be diluted before airbrushing, while some may be airbrush-ready—read the manufacturer's directions. Use light layers of color to build up to the final color of your specimen. In nature, nothing is one-dimensional or

flat, so take the time to study the original color of the part you are painting. Even if you are coloring a part in an unnatural way for a rogue mount, a multi-dimensional color may yield you more convincing results. For airbrushing areas where there is fur (such as an inner ear) you can wipe the excess paint off of the fur or even wait until it dries and use a brush to brush it out.

Although many taxidermists swear by an airbrush, it is a big investment for a thrifty beginner. Don't despair! Keep in mind the Victorian-era master taxidermists who used paint on a brush (and a ton of skill) to restore color. Airbrushes weren't around back then! Put on your game face and devote yourself to brush skills. As with an airbrush, light layers of multiple colors that build up to a final color will always look more lifelike. Since brushes don't work with a fine, aerated mist of paint, you'll need to control the amount of paint you put on the brush, and depending on the application, you may need to let the layers dry between coats. The texture of your brush will be reflected on your surface, so choose a brush accordingly. Some work with makeup brushes and makeup sponges, since they are finely textured and readily available at drugstores. Some also use makeup such as eyeshadow, powder, blush, and other powdery pigments to add color, due to their blendability. Keep in mind that some makeup has a shimmer to it (even if it is not straight-up glitter, small shimmery particles are added to help reflect light when on the face), so be mindful of this as you pick out what to buy. Some people also use these powders over paint. A trip to Sephora will never be the same.

Blending and ombre effects can be accomplished with thin layers of paint with an airbrush, slowly fading one color into the other. With a paintbrush, use a finely textured smooth brush. You can also practice these effects on paper to figure out the

paint recipes and palette. Dry brushing is also useful for blending by brush (use a completely dry brush to apply a small amount of paint over the dried color.)

For antiquing effects, like on certain bird feet, let the main color of the foot dry completely. Then seal it. If you are using a water-based paint, you could use a lacquer-based sealer so that the antique wash can be wiped up easier. (It isn't necessary, but can be helpful.) Use a matte, gloss, or satin-finish sealer based on what you are painting, and let it dry completely. When you apply the antiquing, use a darker or lighter color based on the effect you are going for. Smoothly wipe this all around, getting into the creases and crevices as needed, then use a clean soft sponge or tissue to wipe off the excess. Let this layer dry, the seal it.

To texture a nose, paw pad, or other part, you can buy specialized brushes, such as the Bill Yox deer nose pad, or use household items like sponges and steel wool, depending on the texture you are going for.

SEALING

Whether you are working with paint or makeup, you will need to seal your work. This protects your paint from fading and dust, and it provides a glossy, matte, or satin look, depending on what you want. Make sure your sealer is compatible with your paint. It is a good idea to test it on a scrap or other surface so you don't end up with toenails that are too shiny or a nose that looks too dull.

SCULPTING

It is normal to need to do sculpting around areas that may shrink after death and drying, such as small animal eyelids,

eyerings on birds, nails, etc. Apoxie Sculpt, Magic Sculpt, or any sculpting material can be textured a number of ways. Some choose to purchase their sculpting material in a flesh color so as to provide a base coat that matches the base color of the animal, but this is not totally necessary— you have the power of paint. Keep in mind that hard edges and sharp lines are not common on animals, so be sure to study your reference, whether it is fantasy or traditional.

To smooth it out, use the back of a spoon or a modeling tool and rub. Both companies also sell a safety solvent that can help to further smooth the material.

As with painting, brushes and sponges can be used to add texture. Look at your reference photos to determine the shape, size, and pattern of the texture you want. Based on that, you can use a stiff wire brush, steel wool, a soft bristled brush, a sponge, a scrub pad, or anything else.

For stippled or dimpled textures, a pin, awl, cutting wheel, or even specialized texturizers like a fish scale roller are fun to experiment with.

NOSE JOB

Take a small ball or roll of epoxy sculpting clay and set it inside the nose. Gently spray a cotton swab with glass cleaner and use it to push the ball of clay inside the nose. This will cover the visible clay and seal the inside of the nose. You may have to do this a few times to completely cover it all. Do not completely fill in the nostril, though!

After this step you may need to rebuild the nose a bit on the side wings. To do this just use a tiny ball of clay and lightly push it on to the area with a moist cotton swab. Smooth it over afterwards and shape it if need be. To fix any indents on the top of the nose, put a ball of clay in the indent and push it down into

Nose job

the indent with another cotton swab. To texture the nose, pat a wire brush repeatedly on to the nose wherever clay was applied. Be careful not to apply too much pressure, as this can pick off the clay.

EYELIDS

Take a small rolled-out strip of epoxy sculpting clay and lay it on top of the glass eye right above the eyelid. Start with either the top or bottom lid. Once the clay is laid on top, take a cotton swab coated in glass cleaner, and really smoosh the clay down against the eyelid. Use a toothpick to scrape off the excess clay. Set the toothpick tip on top of the lid itself, but do not pack it down into the lid; that will remove what we just put in there!

Eyelids

Some eyes do not shrink that much, but if you have damage to the eyelids or have pin holes, you may have to work on this step for a little while. Be sure to fill in the tear duct as well using the same process. Also fill in any other little pinholes around the eye this way. After clay has filled in all the little nooks, smooth it over with a moistened cotton swab and remove anything that doesn't look natural.

LIP LINE

To fill in the lip line, roll out a few small strips of epoxy sculpting clay. Set a strip between the top and bottom lips. Smooth the clay into the small gap using a cotton swab. Push the clay in and pull it down as well. Do this process a few times to fill in

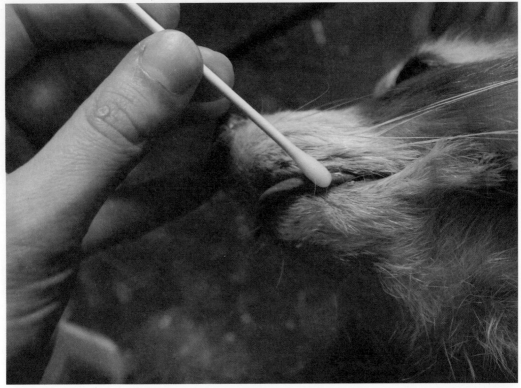

Lip line

the whole lip line. Smooth the clay afterward and gently use a toothpick or modeling tool to create an indent between the top and bottom lip. Then smooth that out even more, making sure to not apply too much pressure and filling back in the indent. The clay can dry within a few hours, but to be sure it is completely set, you can let it sit overnight.

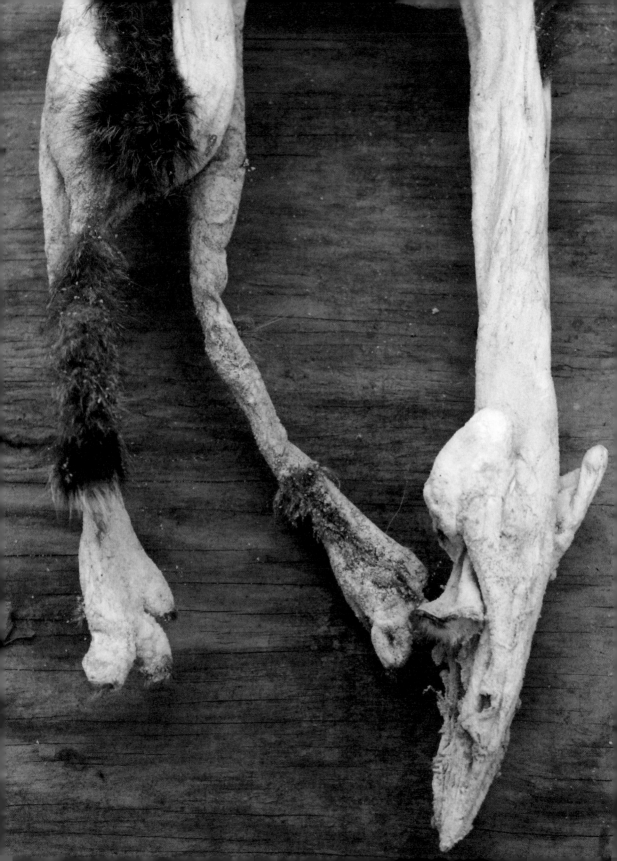

CHAPTER 8
TANNING HIDES

Tanning is what turns a raw pelt into leather by using chemicals and processes to permanently alter the protein structure of a skin. Thanks, science! Traditionally, tanning used tannin, an acidic chemical compound found naturally in oak tree bark, but many other techniques and chemicals were used, including the age-old technique of brain tanning.

In the old days, tanning stunk incredibly, and for that reason tanneries were almost always on the outskirts of town. In some areas, it wasn't uncommon to see children employed as "dung collectors" or gathering whatever was in the "piss-pots"—this organic matter, and the resulting enzyme action one could get from it, was useful in tanning. Animal hides usually arrived at a tannery in a raw condition, and if they were hides to be tanned with the hair off, they could even be decaying. Tanneries also made use of all the leftover bits to make products such as glue. After letting hides deteriorate in vats of water, a glue was made by boiling and cooling what was left.

You've gotta find some poetry in the contrast between this and the sexy leather stiletto that could arrive as the end product of the process. But modern tanning has cleaned up quite a bit thanks to indoor plumbing, stricter environmental regulations, and technology. It is done with safer vegetable or mineral compounds. Although not many of the main ideas and processes have changed, we now have

the ability to work cleaner, and we can produce a wild variety of hides and leathers.

There are also a huge variety of at-home tanning kits for both hair-on and hair-off hides. There are combo tans, which combine a pickle and tan in one solution, such as Krowtann, submersible tans like Lutan F or McKenzie's Tan (a solution in which the skin is submerged), and paint-on tans like Trubond (which is painted onto the skin). By no means are you limited to these three brands. They're just the ones we have experience with, and we recommend trying a few to see which one you like best. There are a bunch of home recipes for tanning too, but we prefer the kits and methods that have stood up to the test of time.

For taxidermy-quality skins, a tan needs to be durable and stretchy. In order for a tan to fully penetrate, there are a few things we have to do: fleshing, salting, and pickling, then neutralizing/basifying and tanning.

FLESHING

We have no qualms about beating this question until it cries for mercy: Why is fleshing so important? Skin is made up of multiple layers; from outside to inside, we have the epidermis, grain, grain and corium, and corium. When buying leather goods, this is how the distinction is made between full grain, top grain, splits, and the parts sold as "genuine leather" (like mystery meat) and suede. Fleshing removes all the obviously gross stuff like fat and excess tissue from a skin, but detail fleshing also thins out the corium, leaving mostly the tannable material of the skin behind. You'll be doing more fleshing and thinning after pickling too, but before salting, you want to get all of the majorly offensive stuff. A tan will not penetrate excessive tissue, and besides that, any fat and goo can go rancid and attract bac-

Fleshing

teria that cause slippage. Yuck! After skinning, you can give it a wash before and during fleshing to remove any excess blood or stains. Be sure to use water that is not too hot or too cold, as you do not want to shock the skin. Depending on end use, you might need to thin the skin.

SALTING

Salting after fleshing dries a skin out, discourages the growth of bacteria, and locks the hair into the skin. To salt a skin, use fresh, non-iodized salt (available in bulk for very cheap at feed stores or online). Lay out your fleshed skin, fleshed side up, on a wire rack that is tilted for moisture to roll onto the floor, and cover it in salt. Rub it in and make sure it covers every little nook and cranny. Salt is cheap, so use it liberally. And don't reuse old, wet, smelly salt.

Replace wet or spent salt every 12–24 hours until the skin is totally dry. You don't want to salt a skin at below freezing (it

won't penetrate) and if it is really hot out, you can do your salting in a cool, dry room with good ventilation (the skin shouldn't smell since you've got it fleshed really well!). Once dried, you can store the skin in a cool dry place until it is ready for tanning day.

REHYDRATING

Always check the instructions that come with your tan on how to properly rehydrate. For most tans, after the skin is salted, it may need to be rehydrated if it is too dry before putting it into a pickle. To rehydrate without encouraging bacterial growth, use a 5 percent salt solution and lukewarm water. Some people use a bactericide or fungicide in this step, but if you don't leave it in for too long, you shouldn't have any problems with bacteria, as you'll be transferring it to the pickle.

PICKLE

A pickle is a bath of acid, salt, and water. Herbs and spices can be added, but save those for your cucumbers. The point of this pickle its to stop bacterial growth, eat away at acid soluble proteins (the ones that are not tannable), swell up the skin to provide more areas for the tan to penetrate, and realign the fibers in the skin to make further fleshing and shaving of the corium layer easier. The pickle bath can be mixed up in a glass or plastic container with a lid (no need for it to be airtight), but never, ever metal. When dissolving the salt in your pickle, it may be easier to use warm water, but make sure the water is not hot when you are adding the skin. You can also add degreaser to your pickle, especially for greasy buggers like raccoons and bears.

To stay effective, the pH of your pickle should always stay low, and you should monitor your pickle at least once a day to make sure it stays acidic. Use litmus paper, protect your skin and eyes, and have fun watching it change color. The ideal pH is below 2,

although we recommend reading the directions that come with your tanning kit and following them closely. As water pH can vary by area, there is no one recipe for pickle, so use your litmus paper.

When adding acid to your pickle, remove the skin, then add the acid. Never add acid directly onto the skin. Also make sure your skin is fully submerged. You can use a milk jug filled with water or another heavy thing to weigh it down—just make sure it doesn't leak into your pickle!

There are a number of acids you can use for a pickle, some more dangerous than others. Find what gives you the best results. If clean, you can reuse your pickle, but you may need to adjust the salinity and acidity for it to stay effective. Your pickle is usually done after 48–72 hours, but it all depends on the hide. Each day when you check the acidity, also check your skin—you can scrape it, flesh it, thin it further, and then put the skin back into the pickle in a different position to make sure the whole skin is contacting the pickle. You can keep the skins in the pickle for longer than 72 hours (some people keep it in for weeks) as long as the pH is maintained. Read the instructions with your kit and the acid you are using to make sure!

NEUTRALIZE AND BASIFY

After pickling you need to neutralize, or basify, your skin. Depending on the tan you are using, the skin needs to become less acidic so it is in the sweet spot where it will absorb the tan. (It isn't totally neutral yet, hence "basify," but the step is commonly referred to by both names.) Depending on the tan used, this pH can be from 3.5 to 5. Most commonly this is done with a solution of sodium bicarbonate (or baking soda) and cool water. Add the sodium bicarbonate to the water until it reaches the pH needed (use litmus paper), and stir the skin occasionally to ensure full contact. If you do not plan on reusing the pickle, you

can also add the sodium bicarbonate to the pickle solution itself. This basifying bath should last 20–30 minutes, depending on the hide and tan used. After this step, additional degreasing and deodorizing can be done as needed. Again, follow the directions that came with your kit.

TANNING

Now you can mix up your submersible tanning solution or paint-on tan. Submerge it in the solution or paint it on following the manufacturer's directions. After soaking in the tan for the prescribed time, remove the skin and admire your beautiful, buttery tanned hide. You can wash off excess tanning solution (keep in mind to check the kit as some tans are not washable or do not require this step). After tanning, you may also need to further thin the skin, especially in the lips and nose areas, depending on the type of tan used. Now it is time to further soften and condition the skin with tanning oil, and, if necessary, to break and/or stretch. For a mounted skin, you will do less breaking than for a skin to be used as a rug or some other more flexible application. Most home tanning kits are wet tans, meaning the skin must be mounted after the tan or frozen until ready to mount.

(If you're using a home kit, *follow the directions.* We can't stress this enough. Each kit is different, so the manufacturer's instructions are the safest and most accurate for that particular product. The above is just a guide to let you know what is going on in each step.)

Be sure to dispose of your pickling and tanning chemicals properly. Not all of them can simply be dumped down the drain (some need to be absorbed into a medium like cat litter, and some need to be neutralized before pouring down the drain.)

SOFTENING

Getting a skin to be soft and flexible doesn't magically happen after coming out of the tan. You've gotta work it. One method for breaking/softening is to lightly blow dry the hair and hang the hide in a well ventilated area. Watch the skin closely, as you want to make sure it is still pliable, and when it is about 75–80 percent dry, apply a high-quality tanning oil to the skin side. Then stretch it and work it over a beam or with sandpaper. You'll see the hide turn whiter as it dries. You can also repeat this process two or three times to further work and soften the skin for a rug or soft application. This is a very labor-intensive process, so have fun and get your upper body workout in! It is manageable to do thinner-skinned animals for home use, like foxes, rabbits, and bobcats, but this part is also one of the reasons why people send skins to a commercial tannery, especially for dry/flexible tans on heavier hides. The thinness of your hide can also affect softness.

This poseable fox needed a soft tan to be flexible

COMMERCIAL TANNING

You may decide that home tanning is more work than what you want to deal with, or that you don't have the space. It's totally fine to send your skin to the pros at a commercial tannery.

When sending a skin out, the best thing to do is get on the phone with the tannery and let them know what you are sending, and ask questions. Every tannery has their own preferences based on their business models, but one thing is true: A good tannery will be happy to answer your questions and ease your concerns, even if you think they are silly. They will let you know exactly what condition the skins need to be in when you send them in. A lot of taxidermy tanneries are family-owned businesses, which is also really cool.

Many tanneries require the skin to be fully prepared when sending, meaning the ears are turned with cartilage removed, the nose is split and thinned, and the lips are turned and thinned, with paws removed to the last toenail, fully fleshed and salted. If you have extra money, you can also send raw skins to a tannery and pay for them to flesh and prep the skin for you. You'll have to send these skins frozen in a cooler with insulation and ice packs, and it is a good idea to wrap the frozen green skin in a few layers of plastic or put in a few bags to further guard against leaks.

Aside from the space you'll save in your own workshop, there are many benefits to using a commercial tannery that specializes in taxidermy tans. They are professionals that have been in business for years, with multi-generational knowledge and combined expertise from a team of people. Chances are, they have seen it all, or at least they have seen enough to know how to fix it. They also have commercial equipment like drums (to tumble skins for softening) and shavers (machine-powered rotating knives that thin skins down with precision), so you don't need to invest in purchasing them yourself, let alone find

room to store these large pieces of equipment. With access to commercial tanning chemicals and the approved facilities and methods for disposal, you can also rest assured that you'll receive a quality tan. However, with high numbers of customers, especially during the busy season, it is not uncommon to wait 6 to 12 weeks for your skin to be returned.

OTHER METHODS

Brains, eggs, tree barks, and urine can all be used to tan skins. Skins tanned with any of these will not create stretchy tans, which are necessary for taxidermy. But it's still fun to

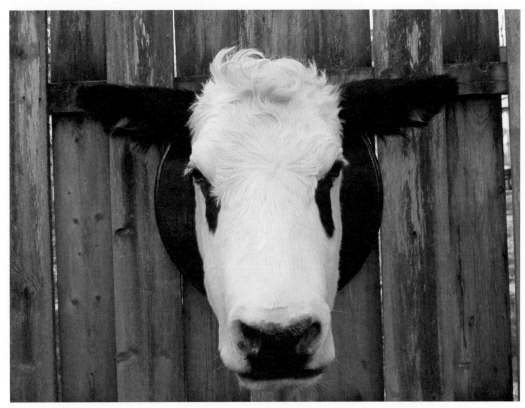

A cow's head tanned using a home recipe

try it out on scrap skins to get an idea of how things worked in the olden days.

BRAIN TANNING

Flesh and scrape your hide, as clean it as you would if you were preparing it for taxidermy. Lay your skin flat and stretch it out so the edges do not crinkle up. While the skin is drying a bit, let's heat up our water and brains in a 50/50 mixture. Almost all animals have enough brain to tan their own hides! Tanning this way uses a method called fat liquoring. This means that as we dry the skin out we are replacing the moisture with fats. Lecithin, the natural tanning chemical found in brains, is responsible for this process. Once the brains are cooked, blend the mixture if need be and slather it on the skin. Be sure to use all of it and to coat to the edges. Allow the mixture to sit until it is all absorbed. After absorbing the brains, we will need to smoke the hide, which helps seal the skin and give it a nice color. You will need to break the skin by rubbing it over an edge to break down the proteins and soften the leather. It's a long process that will make you thankful for your modern comforts!

DRY PRESERVATION

Unlike tanning, dry preservation does not change the chemical composition of the skin. Instead, you are using a powdered chemical like "Instant Preserve" or borax to act as a desiccant, aiding in drying the skin out and making it less attractive to bacteria, bugs, etc. Dry preserving keeps the cellular structure of a skin intact but bug-proofs and dehydrates the raw hide. Dry preservation is totally appropriate for small mammals and thin-skinned animals like birds. The key to good dry preservation is being absolutely sure that your animal skin is fleshed,

degreased, and washed so thoroughly that you could eat off of it. The disadvantages of dry preservative are that the skin will not remain stretchy after drying, unlike some tans, and that the drying process should be monitored more closely to make sure the seams and everything else lies flat and doesn't warp.

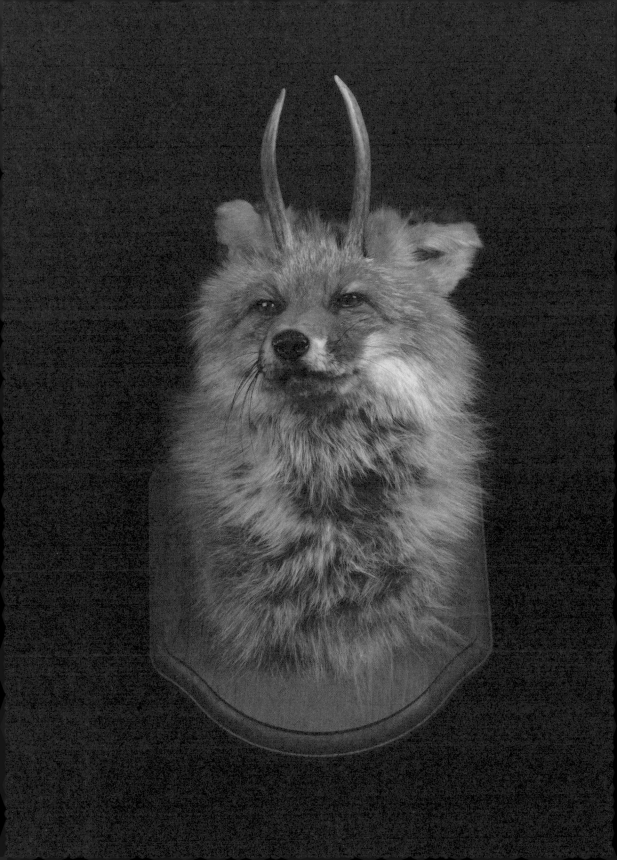

CHAPTER 9
LET'S GET CREATIVE

After getting comfortable with the basic techniques of taxidermy and getting a grasp of animal anatomy, you may be feeling the need to put your own spin on things. Perhaps that is why you got into taxidermy in the first place—to go where no artist has gone before! Or, more accurately, to put your signature on the age-old art of gaff making.

A SHORT HISTORY OF GAFF MAKING

Taxidermy came about as a practical way to communicate and to prove the existence of various animals across the world. As explorations expanded, there were few fact checkers, information traveled slowly, and there was no Internet. So some people decided it would be fun to create fantasy animals and convince unwitting people that yes, these strange beasts and strange lands were real! Sideshow entertainment and curiosity cabinets boomed.

Does P. T. Barnum sound familiar? Before the name became synonymous with expensive popcorn and screaming kids, he charged people a quarter to see his menagerie of mythical creatures, including a living freak show. Some found it in poor taste, but humans have indulged in sensationalism since long before the tabloids. The crowds at these types of shows proved it. Taxidermists, artists, and prop

makers all delighted in making creatures like furry fish, unicorns, faux polycephalics, and most famously, the Fiji Mermaid.

The Fiji Mermaid is one of our favorite gaffs since it speaks to the time and place of its popularity, a very different time than we live in now. We are unsure when the first one was created, but Western knowledge of the Fiji Mermaid can be dated to 1822. Samuel Barrett Edes, an American sea captain, was said to have bought it from Japanese sailors in 1822 for $6,000. He even borrowed the money from the ship's expense account; he just had to have it. He displayed it in London until his death, when Moses Kimball of the Boston Museum purchased it in 1842. P. T. Barnum saw it on display in New York that summer. Although Barnum's expert naturalist said he didn't believe in mermaids, he couldn't figure out how it was made since the teeth and fins were so convincing (there's some variance, but generally Fiji mermaids were made with a combination of juvenile monkey and fish parts). Barnum dismissed these doubts and leased it for $12.50 a week. The mermaid stayed on display in his collection until a fire supposedly burned it all down in the 1860s. But by this time, the concept was so popular that it had been copied multiple times by multiple creators.

A strange case of taxidermy that was not a gaff, but thought to be one, was the platypus. Captain John Hunter sent a platypus pelt along with a sketch of the animal to England in 1798, and British scientists were totally convinced it was a gaff. When sent to the Department of Natural History at the British Museum, George Shaw, who ran the department, claimed to have a hard time believing it wasn't a fake. Coming from a far-off land didn't help the case, and just as with the Fiji mermaid, many thought it was surely the creation of a foreign taxidermist who sewed a bird's bill onto a furry pelt. How else could such a thing exist?!

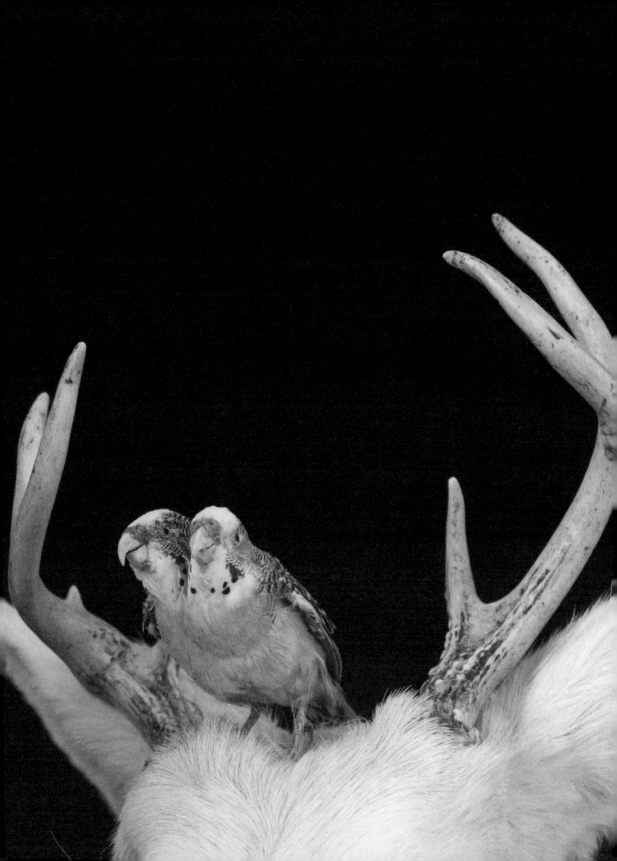

ANTHROPOMORPHISM

During the nineteenth century, a German museum taxidermist by the name of Herrmann Ploucquet sparked a new interest in anthropomorphic taxidermy. For the 1851 Great Exhibition in London, he created a series of tableaus, or scenes from a story. His inspiration came from fables, such as those by Aesop, and popular artist etchings from his time period. His most well known piece is his Reynard the Fox tableaux, showing six scenes from the story.

After Ploucquet, Walter Potter took things a step further. Capturing the whimsy of the Victorian period, he made weird and wonderful scenes such as kittens getting married or a school full of rabbits. Ploucquet was likely an inspiration for Potter; their works have a similar charm. In the twentieth century, a display at the Cress Funeral Home in Wisconsin featured Potter-esque scenes of chipmunks on working miniature Ferris wheels and squirrels in a rowdy bar—complete with miniature bottles of beer, liquor, and miniature squirrel-sized trophy mounts.

The success of anthropomorphic taxidermy is all in the details! Use a specimen that will capture the idea you are trying to convey. Humans are mammals after all, so usually it is easier to insert mammals into these situations rather than birds. Miniature clothes can be made with small bits of fabric and a few stitches, and since you are putting them on critters that will not be walking around or moving anytime soon, you can use well-placed pins, wires, or glue for stability, without worrying about whether the clothes are comfortable. Dollhouse props and miniatures are a great thing to collect if you are going to get into this style, and you can even sculpt your own using clay. Use the paw wires and a corresponding hole in the object to help your animal support anything it may be holding. Simply gluing it in place may not suffice. The fun is in the details, so use references

for the type of anthropomorphic critter you're going to create—whether it is a mousy burlesque dancer or a twerking chipmunk.

HABITATS

There are so many ways to create habitats, and depending on whether you want a fantasy or traditional mount, the habitat plays a key role in the way your animal comes across. You can collect and recreate natural elements such as stones, driftwood, moss, grasses, and artificial water, or preserve your

own plants by drying them out with silica gel, drying salts or glycerin (which will help keep the plant supple). If preserving your plants, be sure they are completely free of bugs and moisture! Depending on the plant, you can use a low oven to dehydrate or kill bugs, use a medical freezer to freeze them, or dip them in mineral spirits to drown them. For more fantasy-style habitats, you can collect miniature furniture or small stools and architectural elements like pedestals from garage sales. Wood pieces are always great since you can build on top of them or use them as is. You can also paint, stain, and finish them in a number of ways. No matter what, your habitat should tell a story about your animal, and your animal should be interacting with its habitat, not overwhelming it.

DYE JOBS

People love color, and it is a great way to add a fantasy element to taxidermy. Dyeing has been used by traditional taxidermists to create replicas of extinct or endangered animals, or just for fun (everyone knows the pink beaver joke). You can dye tanned skins in specialized fur and leather dyes, which are easily dissolved in water. For skins you plan on dry preserving, you can add liquid dyes such as food coloring to your alcohol bath. This may take longer than dyeing a tanned skin, but is ideal for pastel colors. The longer

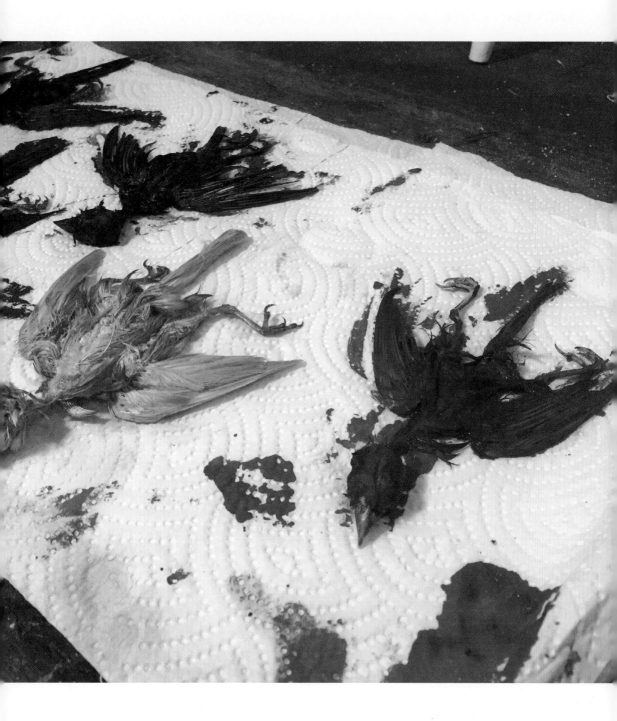

you let it sit, the more intense the color will be, but be mindful of the shrinkage that may occur. Many people also use hair dye on tanned and raw or salted skins (yes, you can even use hair bleach to lighten the skins.) Keep in mind, the dyes are designed for human hair, and animal hair may react differently or may be more sensitive. No matter what dye you use, it is always a good idea to test out dye on a scrap skin from a similar species/color of animal. Avoid dyes that require you to dissolve them in boiling water, especially for raw skins, as this will cause the hair to come loose.

DECK IT OUT

Blending sculptural elements together is another way to make it your own. Standard clay, epoxy clay, paint, natural materials, metal, plastic, foam, and paper are all great materials you can use to alter or add onto a mount.

Try creating your own hybrid skull by sculpting on top a cleaned skull. Sculpt new horns onto mounts or sculpt growths or fantastical adornments. Exaggerate the canines or add on scales or defensive spikes. You can use acrylic or water-based paint to add decorative designs or stories onto bones or hides.

Carving bone or even etching into bone with heat is another great way to customize your creation. You can create a steampunk piece by using scrap bits of metal, or even go as far as making sculptures that look like old toy robots.

WINGS

Before adding any bird parts, make sure your bird is legal to work with! To add wings onto a mount, it is best to prepare them with a little extra skin left on, and keep the shoulder blade patch of feathers so it can blend into your other critter. Try to

pick wings and furred specimens that are similar in color if you're going for a convincing look. Skin, clean, and wire the wings as shown in the bird tutorials, and attach them onto the body using secure hooks as shown for a traditional bird. You can add a little slit on your specimen's back and adhere the wings down into your body for a very close attachment. These wings are not structural or weight-bearing. They are only for looks. Then groom those shoulder feathers and surrounding fur to blend them a bit more. You can also hand-pick some feathers from the rest of the bird you got the wings from to help patch up and fill in any gaps.

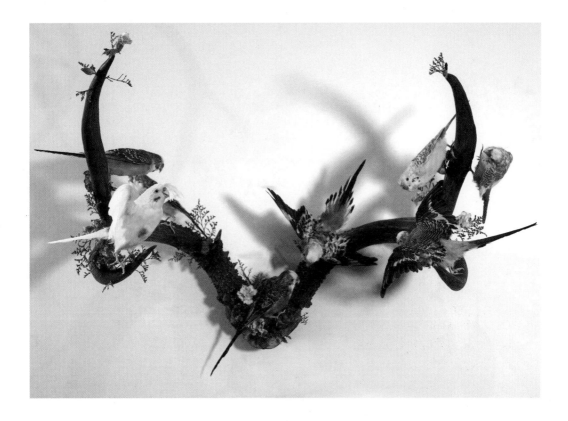

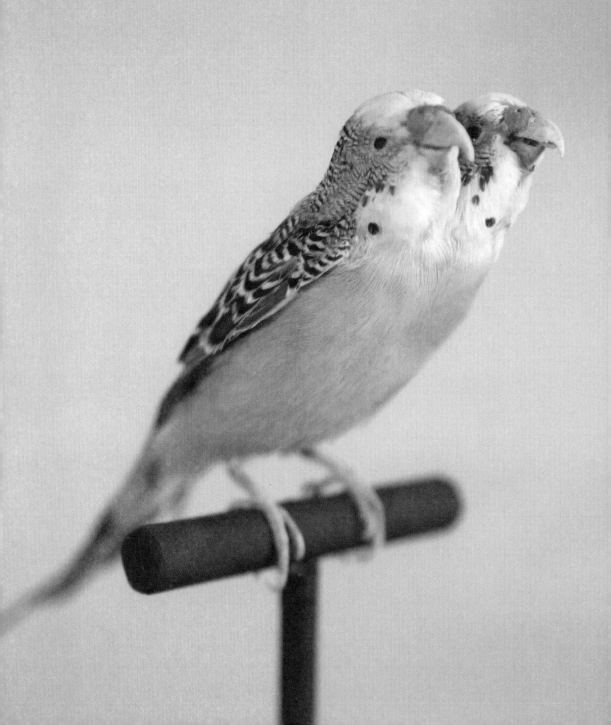

TWO-HEADED PARAKEET

With this tutorial, you'll be armed with basic blending and assembly skills to make a two-headed bird. Polycephaly is a real medical condition, but the popularity of making polycephalic taxidermy mounts has been around since at least the 1800s. Nearly every oddity shop has a two-headed critter (real or fake), and blending two creatures is fun and challenging. For this tutorial, you will skin and flesh two birds. If you ruin your first bird, you will likely be able to salvage the head and then use the body from the other one. These ideas and techniques can be used on other animals too.

SKINNING

You will approach the skinning much like you did in the main bird tutorial. Since parakeets are more delicate, thaw them out in denatured alcohol. This will tighten the skin (kind of like how toner works) and wet the feathers, making it easy to see the apteria. Use your scalpel to make an incision down the breastbone from the base of the neck to just above the vent (Figure 1). Using your fingers and borax for abrasive aid, separate the skin from the carcass (Figure 2). At no point of the skinning process will you be pulling the skin. You will gently push and massage the skin away from the carcass, using borax in the sticky and tough parts. We haven't used borax here since we want to keep the photos clear. Work your way to both hip joints one at a time and sever them. Carefully skin out the tail area next, severing at the vent, and work your way up to the wings (Figure 3). The wings on these small birds are very delicate and there is not a lot of meat, so you can sever them at the shoulder joint and clean the rest later (Figure 4). Then work your way up to the head, working the skin like a tube or a sock, just like you did

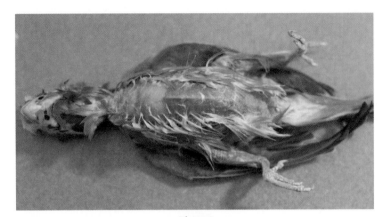

Figure 1

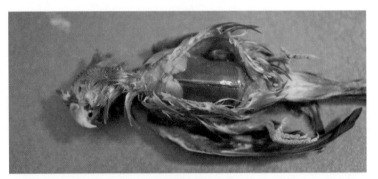

Figure 2

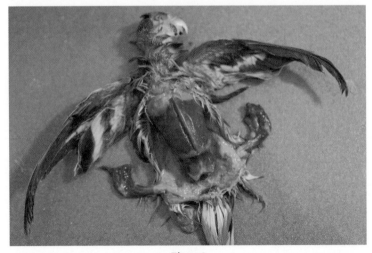

Figure 3

in the other bird tutorial (Figure 5). Once you are at the skull, only work the skin down to right above the beak (Figure 6). Be very careful at the ears and eyelids so you don't tear them. Keep them intact by working slowly. Once the skin is past the eyes and attached by just the beak, you can sever the carcass where the head and the neck meet (Figure 7).

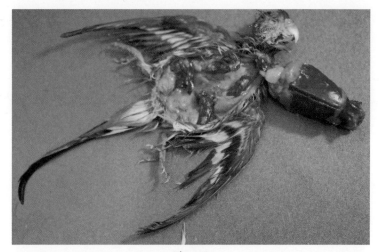

Figure 4

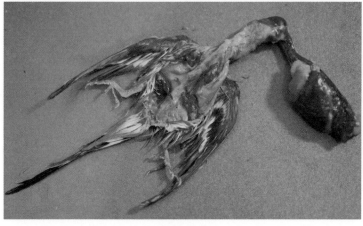

Figure 5

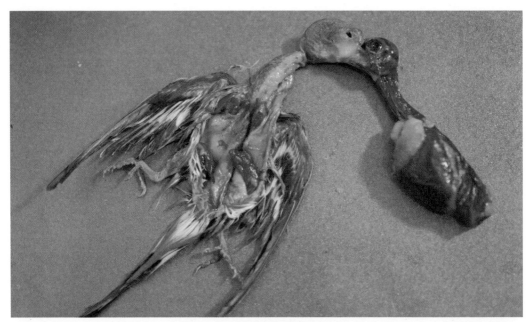

Figure 6

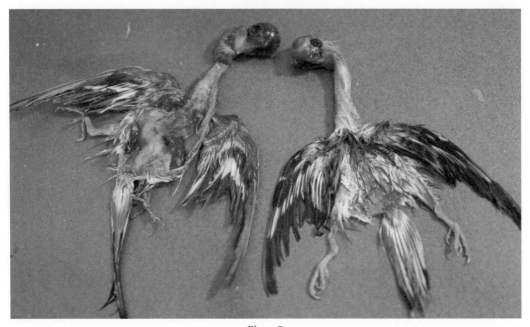

Figure 7

CLEANING AND FLESHING

This goes much like the large bird. Clean the skull by removing the eyes, tongue and soft palate, and brain matter. The leg and wing bones should also be cleaned (Figure 8). You can

Figure 8

slice most of the meat off, but be careful, because the bones are soft. You can use borax to get the bits of meat that are more stubborn, but keep in mind you want to keep the joints and bones all connected. Check for the oil gland at the tail, keeping in mind that it is tiny and sometimes comes out when skinning the vent and tail end. Use your fingers and borax like an exfoliant to flesh the skin, keeping in mind it is really delicate. If needed, you can gently use a wire brush to get between the feather butts, or even an extremely dull scalpel or a butter knife to scrape off stubborn bits of tissue, but be careful not to tear the skin. Once the bones are clean and the skin is fleshed, wash

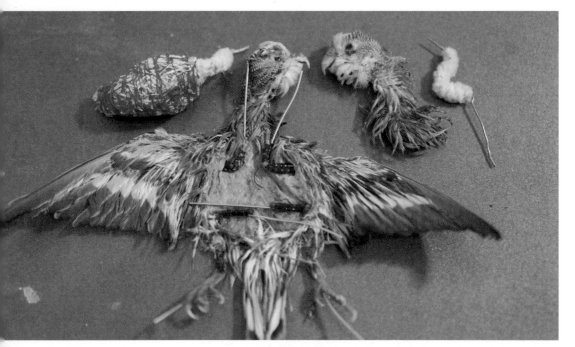

Figure 9

the skin in lukewarm water and Dawn dish soap. Towel dry the bird, and powder with your dry preservative.

ASSEMBLY

Assembly will be similar to your larger bird—we have our body form and our wired legs and wings. Note the S-shape curve in the neck. You can adjust this after you put it into your skin, but it is good to pre-bend it. To get the right shape, use reference pics—try googling "parakeet skeleton" or "parakeet x ray."

For wiring, we used 22-gauge on the legs and neck, and 24-gauge on the wings. Wire the legs and wings as you did with your larger bird (Figure 9). You can use a pin or a sewing needle to help guide the wire through. Here we lodged the wing wire

between the digits, but if you need to have them stick out the wing tips, that is fine (just carefully trim them later!). Once the wires are in, carefully secure them to the bones—we like to use thread to wrap them together—and carefully seal with a combination of super glue and borax. As soon as the borax hits the glue, it sets within seconds and creates a sort of cement. Do this for the two legs and two wings on one of the bodies. You can also wrap cotton or jewelers tow on top of this to recreate the original volume of the legs. Err on the side of under-sizing to make taxiing the skin easier.

You are only using the head of the second bird, so determine where you want to terminate the second head. In this tutorial, we are using all the skin from just above the wings on up (Figure 10). Carefully use a clean sharp scalpel to cut the skin from the flesh side, being sure not to cut the any of the feathers from the outside. For any blending of one animal to another, this is a help-ful technique, whether it is fur or feathers. Cutting from the flesh side helps maintain the natural feather/fur/hairline and helps you better hide and blend your seams.

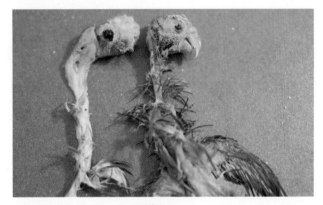

Figure 10

For the head, build it out with clay, add your eyes, and carefully turn it right side out. Feed the neck wire up through the hole you used for cleaning out the

Figure 11

brain and hide the excess, then attach the leg and wing wires onto the body as you did with the larger bird, hooking the wires into the torso and making sure the joints are attached at the correct spots as per your carcass reference (Figure 11). You can remove the foot tendons here too, but remember they are very thin and may present trouble. Here we have left them in and worked the wire around (Figure 12).

To attach the second head, determine where you want it to go on the other body. With a few pins, taxi the skin on the "body bird" and pin the incision shut. Dry preservative may make the skin roll up onto itself, so patiently and carefully unroll it. You may also want to pre-bend your leg and wing wires. When you have determined where you want the second head to come out, you can mark the attachment with a disappearing fabric marker or a pin. Feed the excess neck wire into the body at this point (Figure 13). You can unpin the incision and then use pliers to help feed the wire more securely into the body, then hook the wire into the form to secure it.

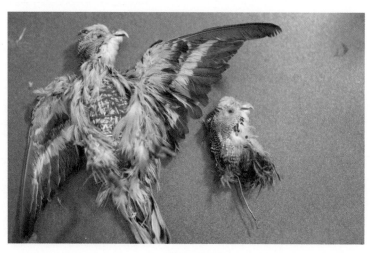

Figure 12

Figure 13

Figure 14

Once everything is wired, you can sew up your incision (Figure 14). If necessary, shake some more dry preserve on the inside to ensure it is fully coated. Use a thin needle and thin thread, making sure your stitches are not so close together that you tear the skin, but also not too far apart so that the skin isn't held securely. Use the same invisible stitch that we used on the

other bird. Once the incision is sewn, use five or six separate stitches to tack down the second head, being sure not to catch any of the down. When you are sewing these parts together, you can also make sure the skin is positioned so the feathers look like they're growing in the same direction as what is around it. Some people also choose to use glue to secure the second head, which can be satisfactory if applied carefully.

PRIMPING AND POSING

You may have noticed we didn't totally dry the feathers before sewing this up. That's because small birds tend to dry out really fast, and we want to keep the skin pliable for as long as possible while sewing and posing. Once sewn and roughly posed, you can powder your bird dry. Here we used a chinchilla dust and borax mix and gently worked it through the feathers with a makeup applicator (Figure 15).

Figure 15

With the feathers dry, you refine the pose of your bird. Adjust the neck curve (Figure 16). Have the heads looking in opposite directions, or even yelling at each other! Adjust the legs and wings into the position you want. Our pose is slightly asymmetric to reflect the asymmetry present in naturally polycephalic crit-

Figure 16

ters. Once posed, you can do your detailed grooming and feather arranging with your tweezers, and you can also use masking tape or thread to train the feathers in place as they dry. (The clear tape used here is plain old tape, made less sticky by applying it to an old towel and peeling it off a few times.) (Figure 17)

If you do not inject the feet, they will shrink, so carefully use a very thin syringe and inject them with the plumper of your choice. If they do shrink, you can use regular clay or epoxy sculpting clay to build them back out, or turn it into part of the look.

If the beak wire is very long, trim it before setting it to dry. Same with your wing wire. Make sure the eye and ear skin on both heads is in place, and use pins to secure if necessary. Insect pins are great since they are very thin and won't leave large holes. Position the feet on foam or a drying stand (here, we used a dowel placed into foam). Check on everything as it dries and reposition as needed (Figure 18).

After about a week, your piece should be fully dry, but check to make sure everything is rock hard—that is, when it is fully cured. You can clean up the eyes, paint the beak and feet after drying, rebuild the cere, and even build the tiniest eyerings with epoxy clay. Cheers to your two-headed bird!

Figure 17

Figure 18

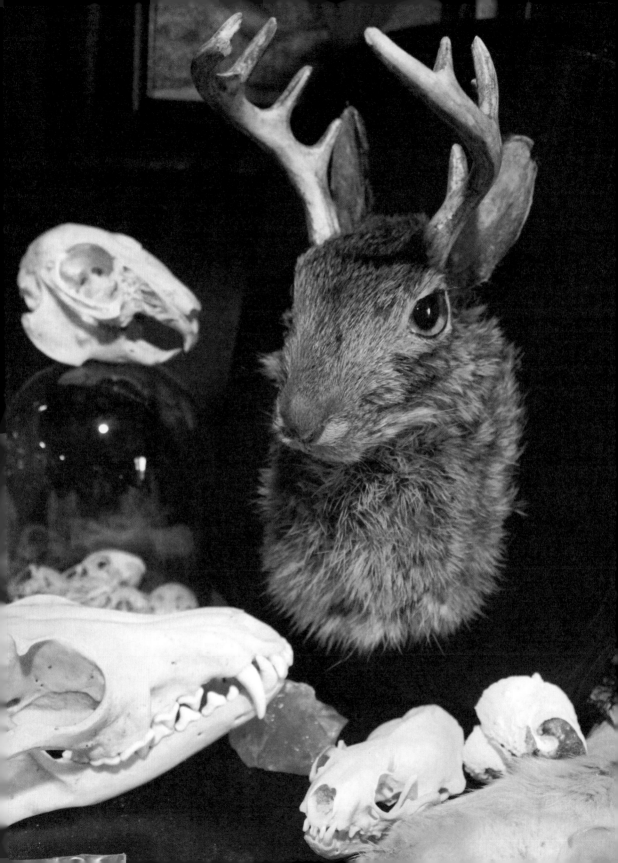

JACKALOPE

A jackalope is a combination of a jackrabbit and an antelope. Jackalopes are often believed to be real by many people. They are often described as magical and rarely seen animals, like Bigfoot or Nessie. Believe it or not, rabbits can suffer from herpes viruses like people, but it manifests differently. Rabbits develop large hard growths (warts) all over their bodies but mainly on their faces. People were seeing these poor herpes-ridden rabbits and calling them jackalopes, mistaking the warty growths as actuals horns or antlers.

To create your own jackalope at home you can mount a rabbit head by carving, wrapping, or using a commercial form (Figure 1). You may need to adapt it to better suit your rabbit's specific anatomy. For this tutorial we are using a commercial form, cast antlers, and a cape-skinned rabbit. Cape skinning is like tube skinning, but from the midsection up. You can use small real antlers or horns, or you can sculpt or cast a pair. You will need to drill into your antlers and securely glue either a threaded rod or piece of wire into them. This allows us to attach them onto our mount later.

Test fit your skin on your form (Figure 2)! Just like the cast rat form, commercial forms need to be roughed up by sanding and cut into for tucking skin.

Ears! Any flexible but strong plastic, like a milk jug, can work (Figure 3). Sculpting clay or body-filling putty work well too. Old school taxidermists used to use sheet lead for earliners! Apply earliner adhesive into your ear cutouts and carefully insert them into your ear pockets. Clean off your marker lines if you are concerned about seeing them. Also be sure to put the right cutout in the right ear—mark them to make it easier (Figure 4). Work the liners all the way to the edge of your ears. If you cannot get it to the edge you probably did not turn them all the way.

Figure 1

Figure 2

Add bits of clay onto your form, filling in the earbutts and eye sockets, and adding onto the nose and whisker areas (Figure 5). Pop your eyes into the clay and build up a basic eyelid shape (Figure 6). Liberally apply hide paste onto your form, but try not to get too much on the glass eyes or go too far back on the form. Otherwise it will slip back and make a mess when we slide the skin on. Gently slide the skin on the form and align the skin in place (Figure 7). Begin tucking the skin and indenting ears into the clay earbutts. Once pinned, fluff up with a wire brush and a blow dryer (Figure 8). Clean up your eyes with a small paintbrush. This also helps soften the skin after tucking it. If your ears were not turned all the way to their edges, card them using painter's tape or screening material (Figure 9). This will help prevent their edges from curling inwards. For the antlers, play around with placement. They can go above the brows or pretty much wherever you want them on the head (Figure 10). For these small casts, the fur can be parted and the antlers can be inserted into the form. You can create a small "X," in the skin with a blade, then insert the antlers. This allows you to tuck the fur around the antler base to make it more realistic. Now your mount needs to be babysat and left to dry (Figure 11).

Figure 3

Figure 4

Figure 5

Figure 6

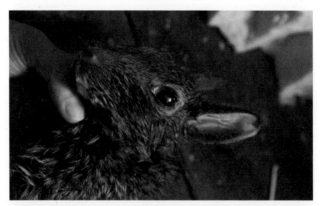

Figure 7

Figure 8

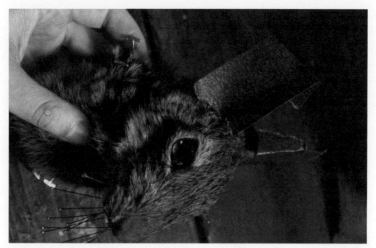

Figure 9

Figure 10

Figure 11

CHAPTER 10
THE WHOLE ANIMAL

There are many uses for your carcasses once the skin is removed and used for taxidermy purposes. You can clean the bones for articulating or jewelry by simmering, macerating, or maintaining a colony of dermestid beetles. You can also create jarred wet specimens for display or create mummies. This chapter will go into detail on the proper way to process these parts. Honestly, most of these processes are pretty stinky. Please work with safety and sanitation in mind. Gloves, goggles, and a mask will all come in handy!

BONE CLEANING

There are a few methods involved in bone cleaning; maceration, burying, using beetles, or simmering. Depending on the space you have and time, any of these methods could work. Keep in mind these methods clean the bones, but it is up to you to put them back together! (Detailed anatomy books are great for this; we love the Lee Post books, which label every single bone and where it goes.)

MACERATION

A fairly easy method, but it is by far the stinkiest. It uses water and bacteria to clean bones. Maceration means to soften or become loose, or to waste away, both

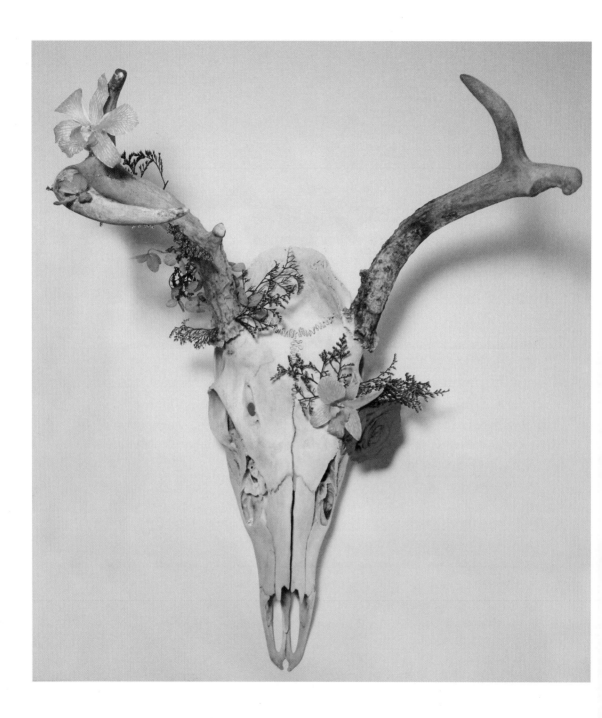

of which suggest visuals that accurately describe this process. The first step would be to gut the carcass and remove as much meat as you can (this process is called flensing). You can throw a whole carcass in, even unskinned, but this is going to slow down the process and is not recommended. The more meat the bacteria have to work on, the more stink you're going to have to deal with. By removing the skin, eyes, tongue, brain, organs, and big meaty chunks, you will greatly speed up the process since you have already started stripping the bones.

Once you have a cleaned carcass, you're ready. Get a bucket with a tight-fitting lid and fill it with water. A five-gallon bucket is great and cheap. Rain or stream water is the best to use, as it already has natural bacteria in it. The chlorine in tap water can interfere with or prolong the rot time. For smaller and more delicate items using a clear glass jar is better since it allows you to keep an eye on the process. Put the carcass in there and pop the lid on. Some folks like to spit in their bucket a few times, as enzymes in saliva can help speed up the cleaning process. Now let it sit from anywhere to a few days to months, depending on the size of the animal you are working on.

A flensed and prepped deer skull can be cleaned in a week if you are able to keep the water warm. The ideal temperature is between 90 to 120 degrees Fahrenheit—the hotter the better, as long as it does not boil! You can also put an aquarium heater in the bucket to keep a constant temperature.

This method smells like nothing you've ever smelled before, so you will need some space to do this and neighbors who aren't very close to your house. To help cut down on smell, you can insulate your buckets in large unused or portable freezers, or insulate with fiberglass insulation and leave them inside a topped garbage can.

Pretty much everything, especially small or young animals,

can fall apart when macerated. The skulls of young animals have not fused at the suture joints on the skull and will become loose when macerated. This isn't bad, but you'll end up with a very laborious and delicate puzzle!

If skeleton articulation is your end goal, it may be best to separate the types of bones and clean them separately. Clean each limb individually to avoid losing tiny little foot bones. Ribs and vertebrae are a bit easier to fit back together, but they can also be cleaned separately. There are three types of vertebrae: cervical, thoracic, and lumbar. You can cut between the vertebrae to section them apart if desired. Using doubled up cheesecloth, mesh, or burlap will help keep small bones together. Teeth often get lost in the maceration process, so the bagging method can help keep all the little incisors with your skull. They are commonly lost during the cleaning process when you go to dump your water. Larger bones need to be drilled into to allow for the marrow to seep out.

You can use this method with fresh specimens or with partially decayed or mummified finds. You will want to gently hydrate the mummified pieces first, then carefully pry off any bits of skin or fur, and any tendons or ligaments that have remained attached. Your fingers and a pair of tweezers or pliers will be your best tools. If something is really stubborn you can use a plastic or soft metal wire brush to scrape any tough bits off.

Bone cages

BONE CAGES

If you have space and are not too close to someone else's property, you can leave your gutted and somewhat cleaned carcasses above ground in cages. You

will want to make sure that the cages are small enough that animals cannot grab items from them, and you should also weigh them down so larger animals do not steal them. This process is also smelly and time consuming, and you are at the mercy of outdoor elements, so you must monitor your cages.

BURYING

Burying is another less stinky option. Once again, gut and remove as much meat as you can from the carcass. Put the carcass in burlap or a few layers of cheesecloth so that you do not lose any little foot bones or teeth. You will want to bury the specimen at least eight to ten inches under the ground and mark where it is placed. This method can take months to years to fully clean the bones. Be sure to mark your bury site. Otherwise it may be difficult to find the remains later!

SIMMERING

If you have a pot or slow cooker you do not care about, you can clean the bones by simmering them too. Use either a ceramic or stainless pot, but not an aluminum one, which can result in discolored bones. NEVER boil! Boiling will make the bones brittle and push fat deep into the tissue, making them smelly or yellow. The amount of time it will take depends on the size of

Burying

your specimen. As with maceration, a temperature between 90 to 160 degrees Fahrenheit would work. If you are using a slow cooker, only use the low setting. The hot setting is closer to boiling, which cold ruin your specimen. Since this is a more active form of cleaning, with higher heat, you will need to watch the bones as they simmer so that you do not overdo it. Once all the meat falls off, you can take the bones out of the water and pick off anything that still remains. Then do another light simmer to remove any other little bits that still may be clinging on.

FLESH-EATING BEETLES

This sounds either really cool or really terrifying, depending on whom you ask. The ideal method for cleaning bones utilizes

Flesh-eating beetles

flesh-eating beetles, or dermestid beetles. Don't worry, they only eat dead flesh (not you or your neighbors) and some organic materials like feathers, fur, and leather. They are little black beetles with white bellies, and their larvae are hairy and brown. Be sure to keep these guys well contained so the rest of your collection does not become their dinner! Sometimes these beetles can be difficult to take care of, and sometimes they require little care. It seems to come down to each specific colony.

An aquarium tank or old chest freezer are great housing devices since the beetles can chew through wood and most plastics. Just make sure your lids are breathable and tight fitting so other insects do not come in. Flies can carry mites and other problems that can kill off your entire colony. You'll need a mix of adults and larvae for a healthy and productive colony. Using an old chest freezer is a great way to build an insulated environment, but often these enclosures have moisture problems and become too humid. Altering a freezer by adding a fan and an air vent to the outside would be the most ideal setup. Using a glass or an acrylic aquarium tank is also great, but you may need to mist the beetles more depending on external temperature or humidity. The larvae like to climb, so watch the corners and edges of your setup. Applying a little petroleum jelly or other slick products will help prevent any escapees. You will most likely have to make a custom-fitting lid if using a tank. Most of the ones available are loose fitting and allow other insects in. Use weather stripping and various grades of mesh or screening to keep your lid secure. The beetles also prefer darker areas, so try to keep them out of direct light.

There are many different substrates in which you can house your beetles: newspaper, cardboard, cotton batting, wood shavings (not cedar though), foam, recycled paper, pocket pet bedding, oatmeal, etc. Keep the substrate half an inch or so deep so

the larvae can pupate in it. Do not use dog food for a substrate. The beetles will eat it instead of the specimens you put in.

The beetles need to be misted every couple of days to ensure a 50 to 60 percent humidity range. Higher moisture can also attract other insects, which can cause severe problems! Mortuary flies and various mites like environments with higher moisture, so keep a close eye out for any symptoms of these hitchhikers, as they can carry mites that will make your bugs sluggish and cause the larvae to appear dusty.

For food, any animal protein seems to work! You will have to skin or defeather your specimens before adding them into your tank. Some colonies prefer specimens that are slightly dried and jerky-like, whereas other colonies prefer wetter, fresher things. Regardless of whether your beetles like dried or wet food, you have to freeze any meaty bits for seventy-two hours before adding them to your tank. If you do not freeze beforehand you may introduce other pests that could kill your colony. To help limit stink and speed up the process, you should flense the specimens as much as possible before giving them to the beetles for dinner. Brain material will create a pretty foul smell if left in, but if the smell doesn't bother you, the beetles and larvae actually love eating brains, and it will help the population get larger. The way you feed your beetles can also affect their moisture content. An undried specimen will create more ambient moisture, so you will not need to mist your bugs as often.

The optimal temperature for your beetles is 70 to 80 degrees Fahrenheit. Any higher, and the adults will begin to fly around, and they can die if it is any. For climates with winter months, a heat lamp or reptile heater under the cage is ideal.

You can forage for wild beetles outside, but be sure to keep them separate and inspect them for mites. You can also buy colonies online in various sizes, but research who you are

buying from first! Buying a variety of adults and larvae is ideal, since the life cycles can take about forty-five days. While larvae begin to pupate, the adults and other young beetles will eat and mate. Beetles do smell, but not as badly as maceration water. Where maceration smells like unbridled, raw death, beetles just smell like death's door. And it isn't really the beetles that smell, but their rotting food and waste. To help limit stink, you should flense the specimens as much as possible before giving them to the beetles for dinner, and dispose waste.

DEGREASING

After any of these methods are chosen, we will need to degrease the bones. You can do a few soaks in water and dish soap, soak the bones in watered-down ammonia, or soak them in acetone. Small animals do not need a lot of degreasing, but fatty animals like bears and raccoons do. Acetone is the better choice when it comes to degreasing small and brittle bones, as

it actually helps solidify the bones, whereas water and soap can make them fall apart (maceration has similar risks). Acetone can also be reused; just freeze your used stuff, pick out the hardened grease from previous uses, then use again. Degreasing takes a long time for big and greasy skulls! Sometimes months! So be patient. Watch for changes in the weight of the bones and grease appearing in the soaking solution, just as it would with soup. Be sure to change the solution as needed.

WHITENING

After degreasing, you want to whiten the bones with store-bought peroxide. The regular ol' three-percent stuff will do. Higher-percent stuff can give you some nasty chemical burns and even explode if stored improperly. NEVER use bleach! It will eat away at the bone and make it chalky and brittle. Even if you do not see the damage immediately, it can eat away at the bone over years and turn it into dust. Some bones may need

multiple whitening baths to get them to the color you would like. Put the peroxide into a non-reactive container with a loose-fitting lid. After the peroxide, sitting the skulls in the sun to dry will also help whiten them. Be sure to not leave them for too long though! The suns rays can become too strong and crack bones or make them brittle if left for prolonged periods. Peroxide can usually be used two or three times, but once it stops fizzing it is time to replace it.

WET SPECIMENS

Creating wet specimens with carcasses or organs is another great way to use the whole animal. They are very useful for anatomical displays and are neat objects to admire. There are some varying opinions on which method makes better long-term specimens.

Many institutions and medical professionals highly recommend fixing a specimen with formalin before storing it in alcohol. Formalin is a diluted mixture of formaldehyde (which is a gas in its pure state) and water. Put your specimen in water first and see how much is needed to fully submerge it. Use this measurement to mix up the proper amount of formalin. You will need to inject your specimen in the abdomen to preserve the intestinal area, the torso to preserve the heart and lungs, and the head. For the last one, you can use full-strength formaldehyde. Let your specimen sit for a period of time between one day and a few weeks. This depends on the size of your specimen; you can leave mouse to rabbit size in for 3 to 5 days. From this solution you will want to soak or rinse your specimen in water. Some people use distilled water, though many have not noticed any advantages to this.

Rinse until the liquid surrounding your specimen stays pretty clear. You are rinsing and leaching excess formalin to

help reduce seepage into your storing solution. Now you can place your specimen in alcohol—denatured, 70 percent isopropyl, and ethyl alcohols will all work. Using ethyl alcohol helps prevent the eyes from becoming cloudy.

Yes, formaldehyde is a carcinogen; so be very careful using it and always wear proper PPE (Personal Protective Equipment). Chemical gloves, a rubber apron, a fume mask, and a face shield are important to use, along with proper ventilation.

Some like to only use alcohol to preserve specimens. The issue with this is that a lot of people forget to inject it into their specimens. If you do not inject alcohol into the specimen, it will rot from the inside out. You should use a 95 percent solution to inject and then submerge and store the specimen in a 70 percent solution. Storing in too concentrated a solution will cause shrinkage of the tissues and color loss. Think about what happens when you put alcohol on your skin: It shrivels. Furred or feathered specimens will not show this well, but organs and fetal specimens will. You can gut whole specimens too, which is recommended, but then you will need to sew the specimen back up if you do not want the innards showing. Specimens fixed in alcohol can break down easily and should not be moved or handled very often. Formalin sets or fixes the tissue by hardening it, and the alcohol preserves the tissue. That is why the two together are the best combo. Either way, specimens should be kept away from sunlight and not allowed to get very hot.

You can artfully display your preserved specimen in a beautiful jar; you will want to make sure that jar has a good seal in it so air does not get in. A mason jar with a non-corrosive lid will do, as will beautiful apothecary jars with tight-fitting lids. There are museums with storage rooms that store specimens in the jars they were collected in for historical accuracy or practicality, so don't feel bad if you are enamored with the idea

of putting your snake in a jar that says "pickles" on it. Just make sure the seal is as airtight as possible. And if any of the alcohol evaporates over time, just top it off with more of the same type.

MUMMIFICATION

Ancient Egyptians used a combination of natural elements to create their mummies. Due to the dry climate and hot temperature, bodies would desiccate fairly easily on their own. The climate, along with the different oils, herbs, and rubs applied to the bodies, allowed the bodies to mummify and not completely rot. Natron, a naturally occurring salt, cedar oil, tree resin, myrrh, spices, sawdust, tar, and cinnamon, along with other spices, were all once used in the mummification process. Believe it or not, honey was actually used to mummify as well! Bodies were and still are prepped in a similar way. A specimen is gutted and drained of fluids, the brain is carefully removed, and then the specimen is rubbed down with resins or tar, filled with herbs or sawdust, then sewn up and positioned. An easy way to mummify a specimen at home is to use a standard oven on the lowest setting or a food dehydrator. Small items can even be buried in borax or a mix of borax, salt, and corn meal. Desiccants can also be used if you stock them in bulk. The amount of time required will depend on the size of your specimen. Routine checks will be needed to ensure rot doesn't set in.

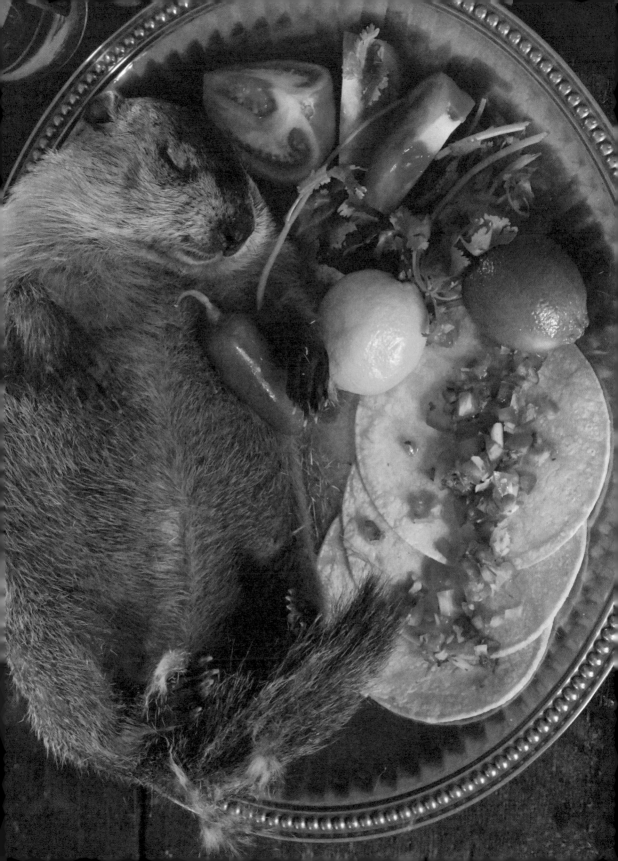

CHAPTER 11
HUNGRY YET? LET'S EAT!

If you have a hunted or farmed an animal deemed safe for consumption, we can't think of any reason NOT to eat it! Of course, it is one experience to go to fine restaurants and have venison, quail, pheasant, duck, and who knows what else served in tiny portions on fine china, but it is absolutely another to use every part of the animal with your own two hands (or four, if you can get someone else to do the dishes!).

For those who eat meat, there are few things that are more meaningful and meditative than using and honoring all parts of the animal. To truly know where your food came from and play an active role in the process—it doesn't get any more free-range or organic than that! If you are vegan, you can look into donating the meat to a food bank, where someone hungry would greatly appreciate it, or try your hand at making some delicious pet treats! That bone marrow you cleaned out of that handsome pheasant? Your cat will love you for letting her lick the spoon! Thinly sliced varmint jerky? Your dog will go nuts!

This chapter will give you recipes for cooking and eating wild and weird game. When skinning an animal for consumption, please do not use borax or other chemicals that are unsafe for internal consumption (salt or cornmeal are safe bets and can provide some of the abrasive quality). If skinning animals for pet consumption, please be considerate of any allergies or intolerances your pet may have. With a bit of mindful handling and preparation, the taxidermy hobby that provides food for your mind can also provide food for your body.

Use safe handling for all wild meat, being sure to work while the specimen is still fresh. Depending on where you live, you may also be able to sign up for a local course on field dressing wild game. We strongly suggest you do this so you can learn about appropriate safety precautions as well as what to look for.

WOODCHUCK TACOS

Woodchuck meat is dark but fairly mild-flavored and tender. Be sure to properly field dress and remove the entrails and fat/scent glands. They are a little darker than the color of butter and are about the size of a lima bean. The hind leg glands are in the rear part of the thighs, and the front leg glands, which are smaller, are near the triceps. It holds up well to brining and slow cooking, making it the perfect star for flavorful tacos.

INGREDIENTS

1 woodchuck, cleaned and quartered, or cut into pieces that will fit into your slow cooker

Water

White vinegar

Seasonings for the brine (salt, sugar, aromatics)

2 large yellow onions, sliced

5–8 cloves of crushed garlic

½ cup lime juice

½ cup orange juice

1–2 jalapeños (or other hot pepper)

2 bay leaves

2 tablespoons cumin

1 tablespoon sweet paprika

½ tablespoon cayenne powder (optional)

Salt and pepper to taste

Fresh tortillas or taco shells

Taco condiments

DIRECTIONS

In a large pot, soak the woodchuck overnight in equal parts water and vinegar. Adding some salt and sugar or honey helps the brine effectively season the meat (with osmosis and such), and you can add aromatics such as onion, garlic, and other seasonings. After soaking, drain, wash, and wipe off the excess brine. Add the meat and the rest of the ingredients to your slow cooker, and cook on low. The meat will further tenderize as it cooks, and when done, it can be shredded with a fork. As the deliciously savory smell of cooking chuck fills your home, warm your tortillas and get your favorite taco condiments ready—raw red onion, cilantro, and a squeeze of lime juice add zip and complement the earthy flavor of the meat, but hot sauce, crumbled cotija cheese, or avocado can add another layer of complexity and texture. Pair the tacos with an ice-cold beer or margarita and you'll wonder why, and how, a varmint could be so delicious.

ROYAL ROAST

The mention of turducken sends people into fits ranging from lust to disgust. The recent popularity of this three-bird party is widely credited to Louisiana's Chef Paul Prudhomme, but the tradition of putting meats into other meats and then into others still has been recorded since Roman times. The Guinness Book of World Records *lists* Whole Stuffed Camel, *supposedly an ancient Bedouin dish served at celebratory occasions for the wealthy, as the record holder for largest single food item. Although we aren't sure if this recipe is real or folklore, it is hard to beat. It calls for 1 camel, 1 lamb or sheep, 20 chickens, 60 eggs, a few fish (depending on your source) and a stuffing made of dates, pistachios, rice, and spices, all roasted over a charcoal pit. Another historic recipe, recorded in 1807 in the* Almanach des Gourmands, *one of the world's first food magazines, is by Alexandre Balthazar Laurent Grimod de la Reynière. This creation was called* rôti sans pareil, *meaning "the roast without an equal." It called for a whopping 17 birds in a range of sizes: warbler, lark, bunting, thrush, quail, lapwing, plover, partridge, woodcock, teal, guinea fowl, duck, chicken, pheasant, goose, turkey, and finally, a great bustard—a bird considered to be one of the heaviest flying birds alive today. The roast recipe we have below is decadent, even somewhat ridiculous, but we are happy to say it does not use protected or endangered species. You can also just choose one of these birds and simply roast it whole.*

INGREDIENTS

1 large quail, 1–2 pounds

1 pheasant, 2–3 pounds

1 duck, 4–4.5 pounds

1 goose, 7–8 pounds

3 pounds ground sausage of your choice (we suggest something with sage), divided

1½ cups chicken or vegetable broth, plus extra for poaching (perhaps homemade from another game bird!)

½ cup Madeira or Ruby Port

2 tablespoons butter

Salt and pepper to taste

FOR THE BRINE: 8 cups water, ½ cup salt, 2 tablespoons sugar, 2 bay leaves, 2 sprigs rosemary

DIRECTIONS

Please note that this recipe has been written for whole birds that have been plucked for feathers, with the skin left on. You can make this recipe with birds you have skinned, and the deboning process will not be as intensive. If you are using skinned birds, you may want to wrap them in bacon and sear them after the poaching step to keep things moist and flavorful.

First, debone all the birds except for the goose. You'll use your taxidermy skills here, giving you an edge over other chefs! To debone, make an incision down the back along the backbone and down into the meat, similar to a dorsal incision. Use your knife to clean the meat and use your fingers to pull out the wishbone and backbone. You can butterfly or fillet the breasts if they are unusually thick. The result is whole, flattened birds that can be rolled up and put inside one another. For the goose, you will cut down the back and remove the backbone, but leave the leg and wing bones in. Sometimes people cut off the ends of the wing bones because they get burnt, but we like gnawing on these weird crispy bits.

Continued

Now make a brine by combining the brine ingredients listed in a large pot and boiling, stirring to make sure the salt and sugar are fully dissolved. The brine will be used for flavoring your quail and pheasant. Let the brine cool completely before you submerge your birds! The quail can brine for about 2 to 4 hours, while the pheasant can brine for 4 to 8 hours. The older and bigger the bird, the longer it should brine. Keep the brine in the fridge while the birds are in it. Remove the birds from the brine and let them sit for 12 to 24 hours so the skin dries out and can get crispy (not necessary for skinless birds). You may also choose to make extra brine for your duck and goose, or you can let them sit in the fridge overnight with a generous rub of salt and pepper. Remove from the fridge and let them sit for 30 minutes at room temperature. Preheat your oven to 475° Fahrenheit.

Lay out your flat quail and spread a thin and even layer of sausage on the inside. Use kitchen twine to roll it up so it stays together while poaching. Bring a pot of broth to simmer over medium heat and cook the quail until the internal temperature reads 140 to 145° Fahrenheit. You can cook it directly in the water, or use a poaching bag. Remove and keep warm, and cut the twine. If you are using a skinless bird, you can remove the kitchen twine, wrap it in bacon, and sear the bacon in a pan until it is crisp. You now have a quail log.

Next, take your pheasant and spread the sausage on the inside, and place your quail in the center. Roll up the pheasant, overlapping the skin to secure and seal in the quail. Poach the pheasant in the same manner as the quail until it is firm to the touch or the internal temperature is 155° Fahrenheit. Remove from the poaching liquid, and remove twine. Same rules here about the skinless bird/sausage/searing. If you have a bird with the skin on, you can sear the skin to get it crisp. But be mindful of overcooking, and keep it warm.

Now take your duck, spread it with sausage, and place your pheasant/quail log inside of that. Roll it up and seal it, using kitchen twine if necessary, and poach for about 30 minutes until firm to the touch. After poaching, the same

rules apply with the skin. You can wrap bacon around the bird and sear it if it is skinless; if it has the skin on, sear it directly until the skin is crispy. Duck renders a lot of fat while it cooks, and you can save this fat to use when roasting vegetables later on.

It's time for the goose. Spread with sausage, put your duck/pheasant/quail log inside, and seal with the skin and kitchen twine. You can use a clean needle and a thin kitchen twine to sew it shut for an even more convincing "oh I'm just a goose, I'm not saying whether there's anything else inside me" effect. You can also truss the goose, using kitchen twine in order to ensure a crispy skin.

Place the goose in a roasting pan with a wire rack, breast side down, and put it in the oven. Roast until the breast is browned, 20 to 30 minutes. Then baste the bird with rendered fat and roast for another 30 minutes. Reduce the heat to 350° Fahrenheit. Roast the goose until the thickest part of the thigh registers 165° Fahrenheit on a thermometer and the juices run clear, about 60 to 90 minutes more. Baste every 30 minutes and transfer excess accumulated fat to a bowl. Once cooked, remove the goose and let it rest on the wire rack on a board or other surface. Transfer any excess fat in the pan to the bowl of collected fat. Now put the roasting pan across two burners over medium-high heat. When the pan juices boil, add the wine and simmer, scraping up the browned bits from the bottom of the pan with a wooden spoon as the alcohol evaporates, about 2 minutes. Add your broth and simmer until the volume of liquid is reduced by a third and becomes gravy-like, about 6 minutes. If you want, you can strain the sauce through a fine-mesh strainer into a saucepan, or just keep the rustic brown bits—we won't tell. Add the butter, and whisk it into the gravy until it is melted and incorporated. Add salt and pepper to taste.

Serve with a really nice bottle of wine. Tell the folks at the wine store what you're making so they suggest something, then invite them over, because you have made a buttload of food!

DUCK (OR GOOSE, OR REALLY
ANY ANIMAL) FAT POTATOES

*It is a shame to waste all the fat from fleshing or from rendering in your
other recipes. Fat equals flavor, and although we would not recommend
eating something like this daily, indulgence is very healthy in moderation.
Remember to use fresh, clean fat here—nothing from an old fleshing
wheel and definitely nothing that has come in contact with dirty tools!*

INGREDIENTS

4 russet potatoes (about 2 pounds)

½ cup rendered duck fat or any other fat (If you are using fat you have saved from
 fleshing, render it in a saucepan. You can also add garlic or herbs to it, but be careful
 not to let them burn.)

For Herb Butter

2 teaspoons minced garlic

1 tablespoon unsalted butter (yes, fat gets better with butter added to it)

4 tablespoons minced fresh parsley leaves (any herbs, including a mixture, work, but
 reduce the amount if you are using stronger herbs like sage or rosemary)

Salt to taste

DIRECTIONS

Preheat oven to 325° Fahrenheit. Cut potatoes into even 1-inch cubes. We
like leaving the skins on our potatoes, but some people peel them. Their loss!
Make sure your potatoes are very dry, and pat them with a paper towel if
needed. In a 12-inch heavy skillet (preferably cast iron since it can go into
the oven), heat your fat over moderate heat until hot but not smoking—you
don't want to burn it. Add potatoes, stirring to coat with fat, and roast in
your oven. Turn the taters every 15 minutes, until crisp, golden, and evenly
cooked. It should take about 45 minutes, but keep checking as all ovens
vary. As they cook, make the herb butter. In a small saucepan, cook garlic in

butter over low heat and stir as needed. In about 3 minutes, the garlic should be soft. Remove it from the heat and add the herbs. The potatoes have probably absorbed all the fat, but you can mix any little bit left with the butter if it is not too burnt. Toss all of this together with salt, and enjoy it while hot.

VAGUELY MIDDLE EASTERN
ROASTED PIGEON
WITH BULGUR WHEAT

There is a long, rich, and flavorful tradition of eating pigeons and squab across the numerous cultures of the Middle East. This recipe uses techniques and spices from throughout the region. This part of the world has raised, hunted, and lived with pigeons for centuries, and knows exactly how to cook them. Some say pigeons are gamier than squab (young, domestically raised birds of the same species) and not as tender, but we enjoy the heartier, richer flavor of the adult birds, and the lack of tenderness can be corrected with a good brine. But even the adult birds are small, so plan on serving one per person. The recipe is written for one. This recipe is written for a skinless bird but can be easily adapted for one with skin.

INGREDIENTS

FOR THE BRINE: ¼ cup salt, 4 cups water, 3 lemon slices, 2 tablespoons honey,
 1 smashed cardamom pod, ½ teaspoon cumin, ½ teaspoon coriander (can use more
 spices for a stronger flavor)

1 pigeon

1½ cups chicken or vegetable stock

¼ cup chopped fresh mint

½ teaspoon cinnamon

¼ teaspoon allspice

½ teaspoon ground cardamom

½ teaspoon ground cumin

¼ teaspoon Aleppo pepper (if you like a kick)

½ cup bulgur wheat

2 tablespoons butter

1 shallot, minced

¼ cup chopped walnuts

Juice of 1 lemon

Salt and pepper to taste

Pomegranate seeds or pomegranate molasses to garnish (optional)

DIRECTIONS

Bring brine ingredients to a boil, and let cool completely before submerging the bird for 6 to 12 hours, depending on the age and size of the bird (bigger/older = longer brine time, and remember to brine your bird in the fridge). When you remove the bird from the brine, you can let it sit in the fridge so the excess liquid comes off, especially if you have a bird with the skin on it. If you are using a skinless bird, blot off this liquid so your meat doesn't get too soggy.

Preheat the oven to 350° Fahrenheit. Place the pigeon breast-side down in an ovenproof pan and roast for about 20 minutes. Then turn breast-side up and roast for another 15 minutes. If you want it crispy, you can turn the heat up to 475° Fahrenheit for the last 10 minutes, but be careful of drying out a skinless bird. Let the bird rest for 10 minutes before serving.

To cook the bulgur, bring the stock to a gentle boil and add the spices, whisking them in so they're incorporated, then add the bulgur. Simmer until it absorbs the liquid. In another pan, melt the butter and fry up the shallot and chopped walnuts. You can cook the shallot until soft and light brown or go full crispy, but if you take the latter option, wait to add the walnuts, as you don't want to burn them. Add the cooked bulgur to this mixture and toss it together. You can also stir in a few pomegranate seeds for texture and flavor garnish.

To serve, plate the pigeon on top of the bulgur and spritz with some lemon juice and salt and pepper to taste. You can drizzle with pomegranate molasses if you like, but don't overwhelm the deliciousness of the pigeon.

TREATS FOR YOUR PET

This recipe can be made with nearly any meat you get that is fit for consumption. Perhaps there is an extra-tough cut that you don't want to eat, or you have a few fresh starlings and sparrows and don't want to cook them as tiny meat treats for yourself.

INGREDIENTS

Meat fit for consumption

Salmon oil or other oil suitable for pet consumption (optional)

DIRECTIONS

Slice the meat very thinly using a sharp knife. Using a brush, lightly coat it with the salmon oil. Preheat your oven to 175° Fahrenheit, and arrange the slices in a single layer on a baking tray. Bake until treats are dry, 4 to 6 hours. You can also use a food dehydrator.

JERKY

Though it has a reputation as a gas station accompaniment to Mountain Dew, good jerky is a delicious and healthy snack. One of the first jerkies we know of was pemmican, a mix of lean meats with fruit that was dried out over a fire or in the blazing sun, made by indigenous Americans as high-energy, practical snacks for long and active days. Because it was dry, it was also lightweight and portable, providing the ultimate bang for the buck in regards to nutrition. Settlers and fur traders saw the value and ingenuity in this tradition and adopted this food for their palates.

INGREDIENTS

2 pounds meat (deer, beef, buffalo, sasquatch, etc.)

FOR THE BRINE: ⅔ cup Worcestershire sauce, ⅔ cup soy sauce, 2 teaspoons
ground black pepper, 1 teaspoon onion powder, 1 teaspoon garlic powder,
1 teaspoon liquid smoke, 1 teaspoon red pepper flakes, 1 tablespoon honey

DIRECTIONS

Slice the meat along the grain, making thin uniform slices. Your new knife skills will come in handy! Mix brine ingredients in a zip-top plastic bag, and add the sliced meat. Smoosh and swoosh everything around so all the brine bathes all the meat. Squeeze the air out of the bag before sealing it (you can use a straw to suck the air out very carefully!). Refrigerate for 3 to 6 hours. More time in the refrigerator will mean stronger flavor. Drain the meat and discard any leftover brine. Turn your oven to 175° Fahrenheit, or as low as it can go. Place the dried strips on a wire rack or wire tray, and dry the strips out. Some people keep the oven door a little ajar so it doesn't get too hard (you can use a log of aluminum foil or another oven-safe material for this, but please don't leave your oven running unattended or without your smoke and CO2 alarms in good working order, as they should be anyway). Depend-

Continued

ing on how hard you like your jerky, you can let it dry for 8 to 12 hours, or even longer if you like it super-chewy. The finished jerky should last for quite some time if stored in an airtight bag or container. Keep in mind that we haven't used any added preservatives, so if you see mold or something growing after a while, don't eat it. To prevent this, you can find food-safe silica gel packets and use some of those in your jerky storage bag. (Keep in mind, you cannot eat the silica gel! It is just to absorb any moisture that may be left in the jerky). We will leave it up to you to determine whether you'll pair this with Mountain Dew. Honestly, we think it goes better with beer or wine.

VENISON BURGERS

Of all the wild game meats, venison is probably the most popular. Although we love a perfectly cooked venison steak or roast, there is something about the fun portability and customization of a burger. It is also a great way to introduce your non–game-eating friends to the delicious wonders of truly free-range, wild, organic, sustainably sourced meat. Because deer are lean from running around in the woods all day, they don't have as much fat as beef. Since fat is important to the flavor of a burger, we have used bacon fat here. You can also use lamb fat or any other fat you like (butchers will sell this to you very inexpensively, if not for free, since nobody really knows what to do with it). We use an 80/20 mix of lean meat to fat; however, you can adjust this to your taste. If you are able to grind your own meat, you can grind the fat right into the meat and control the texture and consistency of your burger (coarse vs. rough, or a mix of the two). If you get your meat ground at a butcher shop, you can ask them to do this for you, or just mix the ground meats yourself.

INGREDIENTS

½ pound fat

1½ pounds venison (meat from the leg, shoulder, ribs, or other parts that are not as tender are ideal)

1 tablespoon Worcestershire sauce

1 garlic clove, finely minced

1 small shallot, finely minced

Salt

Black pepper (grind it fresh!)

4 tablespoons butter, divided

Burger buns, toppings, and condiments of your choice

Continued

DIRECTIONS

Gently mix the fat with the meat, Worcestershire sauce, garlic, and shallot, incorporating it all evenly. You don't want to overwork the meat, and at this point, you really shouldn't be squeamish about using your hands! Divide the meat into patties—they can be somewhat loosely formed—and don't overwork the meat! You can make six city-size burgers or four wilderness-size burgers with this amount of grind. Right before cooking, salt and pepper the outside of your burger to your liking. You can make a mini burger to test out the amount of salt and pepper. Keep in mind, the fat you use is salty, as is the Worcestershire sauce— it would be a shame to over season the meat! Melt 2 tablespoons butter on a skillet or cast-iron pan, and cook the burgers to desired doneness, flipping once to cook each side. Add more butter as needed for cooking.

You can also grill these burgers, although you may need to add an egg as a binder, depending on the consistency of the meat. Once cooked, bun and dress your burgers. In the summer, a toasted ciabatta bun, raw onion, tomato from the farmers' market, and a smear of mustard work well. A burger with toasted brioche, grilled onions, wild mushrooms, and a dollop of gorgonzola is great in the fall. Do what your heart desires!

PAN-FRIED PARMESAN SQUIRREL

Squirrel is actually really good, and not to be cheeky, but it has a sweet and nutty flavor. The number of puns in this recipe description is already at a maximum, so without getting too silly, we present the recipe below.

INGREDIENTS

3 squirrels, cut into even pieces

2 cups buttermilk

2 cups flour, seasoned with salt, pepper, and seasonings of your choice (such as garlic powder, chives, rosemary, or paprika)

3–4 eggs and a healthy splash of cream

2½ cups Parmesan cheese, finely grated

Oil for frying

Continued

245

DIRECTIONS

Soak the squirrel in buttermilk for a few hours before cooking. You can soak for as few as 6 hours or else overnight. Pat dry, then coat in flour that has been seasoned with salt and pepper, adding garlic powder, smoked chili, chives, or dry spices of your choice. Now dip the squirrel into the egg–cream mixture, then coat in finely grated Parmesan cheese. Once coated in the cheese, the squirrel is ready to fry. Heat the oil in a heavy-bottomed pan suitable for frying, and carefully add in the squirrel. Let it cook until the meat is golden brown and no longer pink, about 10 minutes each side. Remove the meat from the pan, cool on a wire rack with paper towels to absorb any excess oil, and enjoy! Be careful of the little bones!

MUSHROOM-BRAISED RABBIT

Elmer Fudd was right; rabbit stew is delicious. Braising is an excellent way to cook rabbit, as the meat takes on the hearty flavors of the wine and mushrooms. You can also adapt this recipe for your slow cooker, making it a perfect way to taste the wilderness on a weeknight.

INGREDIENTS

1 rabbit, 2–3 pounds

¼ cup flour, seasoned with salt, pepper, and spices of your choice

4 tablespoons olive oil

¼ cup red wine

Splash of balsamic vinegar and water

1 small onion, cut into large chunks

3–5 garlic cloves, minced

4 sprigs thyme

2 sprigs rosemary

2 sage leaves

1 pound mushrooms (button, cremini, Portobello—any kind will do!)

Splash of heavy cream

Salt and pepper to taste

DIRECTIONS

Cut the rabbit into manageable pieces, and coat them with seasoned flour. Then, in a skillet with the oil, fry the rabbit for 6 minutes on each side until it is an even golden brown. Remove the meat and add in your wine and a splash of vinegar and water. Scrape all the browned bits off of your pan. Then add in your onion, garlic, herbs, and mushrooms. Heat your oven to 350° Fahrenheit and put your rabbit into an oven-safe pan. Once the mushrooms are cooked or mostly cooked, pour this mixture over your rabbit. Add salt and pepper to taste. Cover the dish with tin foil and cook for 45 minutes. Cook until the meat is tender and the sauce is thickened. Enjoy as-is or accompanied with roasted root veggies or noodles.

RESOURCES

Art stores, hardware stores, and drugstores are all good bets. And don't forget to check secondhand stores too.

TAXIDERMY SUPPLIERS

Al Holmes Supply
alholmessupply.wix.com/supply#!

Badger Air-Brush
www.badgerairbrush.com

Eyeconic
www.eyeconicstore.com

Excel Blades
www.excelblades.com

Havel's Blades
www.havels.com

Joe Coombs Classics
www.joecoombs.com

Jonas Supply Company
www.jonas-supply.com

Matuska Taxidermy
www.matuskataxidermy.com

McKenzie Taxidermy Supply
www.mckenziesp.com

Ohio Taxidermy Supply
s509656365.onlinehome.us

Research Mannikins
www.rmi-online.com

Revolution Taxidermy Supply
www.revolutiontaxidermysupply.com

Smooth-On
www.smooth-on.com

Taxidermy Arts Supply Company, or TASCO
www.taxidermyarts.com

Tohickon Glass Eyes
www.tohickonglasseyes.com

Van Dyke's Taxidermy Supply
www.vandykestaxidermy.com

Wildlife Artists Supply Company, or WASCO
www.taxidermy.com

ACKNOWLEDGMENTS

There are so many people I'd like to acknowledge for their role in making this book happen. My publisher and coauthor, this wouldn't have been possible without you. Aside from all the professional stuff, Katie, you're a most excellent road-trip buddy. My dear husband who has been supportive through my late work nights and creative crises—his thoughtfulness has grounded me through it all. My family who loves unconditionally. My cat who sasses unconditionally. My besties Cedric, Colin, Eddie, Jethro, Laila, Moody, Mari, and Willy. To professionals and mentors at the New England Association of Taxidermists, Garden State Taxidermy Association, United Taxidermists of New York, Nate Hill, Baron Ambrosia, Robert Marbury, Paul Koudounaris, NYC Taxidermy Collective, Heather Bowser, and everyone on taxidermy.net that has given free advice worth millions. To every student who has taken a class, or client who has commissioned work. To all those I've worked with who knew me back when being a full-time artist was a distant dream, to now, and beyond. You've offered your homes, hearts, and pieces of yourselves—thank you. And to the beauty of wildlife, of which I will forever be in awe, by which I will strive to do justice.

—Divya Anantharaman

I would like to thank my publisher for the opportunity and endless thanks to Divya, as a coauthor and as, more important, an amazing friend. Without your encouragement and grounding advice, this would not have been possible. Thank you to my family and especially to my dad, who helped jumpstart me in this direction in life and for the endless love and continued support. Thank you to Havoc, my loyal best friend and endearing cat husband. To Paul Koudounaris and Jamie

Roadkill—thank you both for being some of my closest friends and for all the heart-felt and positive advice when I really needed it. Thank you Paul for inviting me to wondrous scenic destinations and many new experiences. To Caitlin Doughty and Robert Marbury, for all the random texts and problems they have helped me figure out. To Shasta for keeping my fox son safe, and to the NYC Taxidermy Collective, Dakotah, and Lauren for all the love. Thank you to all my friends who have been there for me and have offered up their homes while traveling. To everyone who has helped me on this path, through hands-on workshops, home/studio visits, and various conventions and seminars. Thank you to everyone who has attended a class or bought something from me. Finally, thank you to nature for creating such a vast variety of beautiful animals and environments in which I try to constantly sur-round myself.

—Katie Innamorato

INDEX

ABOUT THE AUTHORS

Divya Anantharaman is a New York City artist whose taxidermy practice was sparked by a lifelong fascination with the intersection of natural mythology and science. With a combination of self and professional training, she left behind a corporate design career to pursue an art form devoted to the preservation of wildlife. She teaches taxidermy workshops at museums, universities, and galleries nationally and internationally. She is a board member of the New England Association of Taxidermists, regularly competes in state shows, and has won Best of Show, Best of Category, blue ribbons, and other honors. Her work is on display in the Chamber of Wonders at the Walter's Art Museum. She enjoys volunteering with NYC Audubon, camping, birds, cats, and glossy black lipstick. You can find out more at www.friendsforevertaxidermy.com

Katie Innamorato is a taxidermy artist and a full-time feral fox human. Her lifelong love for animals and art led her to this career path. She spends most of her days working, playing with her animals, or exploring outside. She enjoys cuddling cats, animal onesies, forensic medicine, jerky, and aspires to owning a small, self-sufficient homestead. She has teamed up with The Field Museum for an educational video on The Brain Scoop, and taught classes for the New York State Department of Environmental Conservation. She is a member of various state taxidermy associations, and has won awards for her work. You can find out more at www.afterlifeanatomy.com.